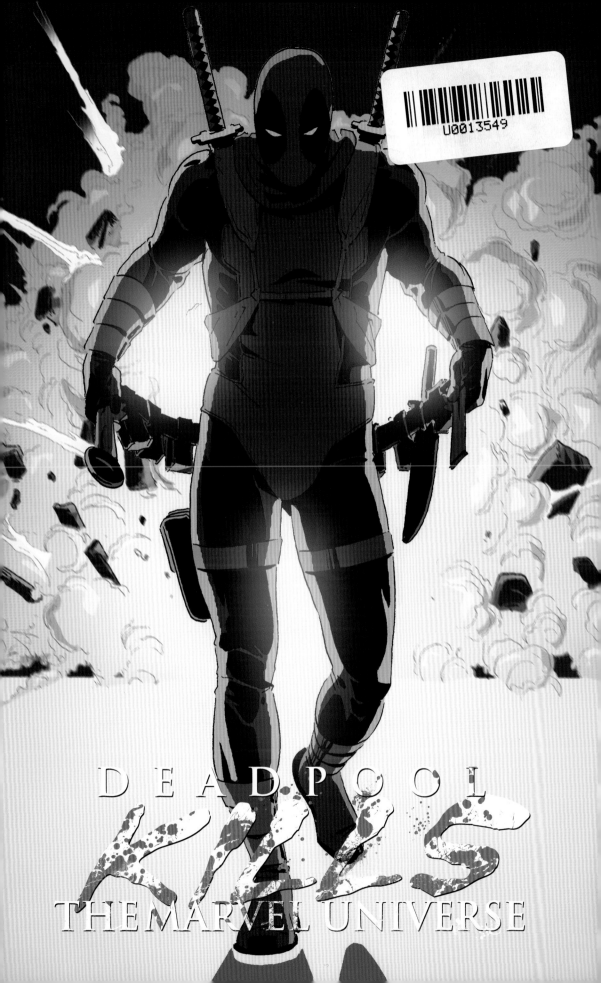

DEADPOOL
KILLS
THE MARVEL UNIVERSE

死侍屠殺漫威宇宙
(Deadpool Kills the Marvel Universe)

故 事 編 劇／庫倫·邦恩 (Cullen Bunn)
繪 圖 作 者／達利波·塔拉吉克 (Dalibor Talaji)
插 畫 上 色 師／李·洛瑞奇 (Lee Loughridge)
植 字 師／VC's 喬·薩比諾 (VC's Joe Sabino)
封 面 繪 圖／卡瑞·安德魯斯 (Kaare Andrews)
原 作 編 輯／喬丹·D·懷特 (Jordan D. White)
原作資深編輯／尼克·洛威 (Nick Lowe)
譯 者／林永翰

執 行 長／陳君平
榮 譽 發 行 人／黃鎮隆
協 理／洪琇菁
執 行 編 輯／石書豪
美 術 總 監／沙雲佩
美 術 編 輯／陳聖義
國 際 版 權／黃令歡、高子甯、賴瑜妗
文 字 校 對／施亞蒨
內 文 排 版／尚騰印刷事業有限公司

漫威工作人員
Deadpool created by **Rob Liefeld** & **Fabian Nicieza**
Collection Editor & Design: **Cory Levine**
VP Production & Special Projects: **Jeff Youngquist**
Associate Editor, Special Projects: **Caitlin O'Connell**
VP, Licensed Publishing: **Sven Larsen**
SVP Print, Sales & Marketing: **David Gabrel**
Editor in Chief: **C.B. Cebulski**

出版／
城邦文化事業股份有限公司　尖端出版
台北市南港區昆陽街16號8樓
電話：(02) 2500-7600　傳真：(02) 2500-2683
E-mail：7novels@mail2.spp.com.tw

發行／
英屬蓋曼群島商家庭傳媒股份有限公司城邦分公司　尖端出版
台北市南港區昆陽街16號8樓
電話：(02) 2500-7600　傳真：(02) 2500-1979

書籍訂購／
劃撥專線：(03) 312-4212
戶名：英屬蓋曼群島商家庭傳媒(股)公司城邦分公司
劃撥帳號：50003021
※劃撥金額未滿500元，請加付掛號郵資50元

國內經銷商／
台灣地區總經銷／中彰投以北(含宜花東)　楨彥有限公司
電話：(02) 8919-3369　傳真：(02) 8914-5524
雲嘉以南　威信圖書有限公司
(嘉義公司)電話：(05) 233-3852　傳真：(05) 233-3863
(高雄公司)電話：(07) 373-0079　傳真：(07) 373-0087

海外經銷商／
香港地區總經銷／城邦 (香港) 出版集團 Cite (H.K.) PublishingGroupLimited
電話：852-2508-6231　傳真：852-2578-9337
E-mail：hkcite@biznetvigator.com
馬新地區總經銷／城邦 (馬新) 出版集團 Cite (M) Sdn Bhd
電話：603-9057-8822　傳真：603-9057-6622
E-mail：cite@cite.com.my

法律顧問／
王子文律師　元禾法律事務所
台北市羅斯福路三段三十七號十五樓

ISBN／9786263065659
2021年8月1版1刷
2024年4月1版2刷

This translation of "Deadpool Kills the Marvel Universe", first published in 2012,
is published by arrangement with MARVEL WORLDWIDE, INC., a subsidiary of
MARVEL Entertainment, LLC.

MARVEL © 2021 MARVEL

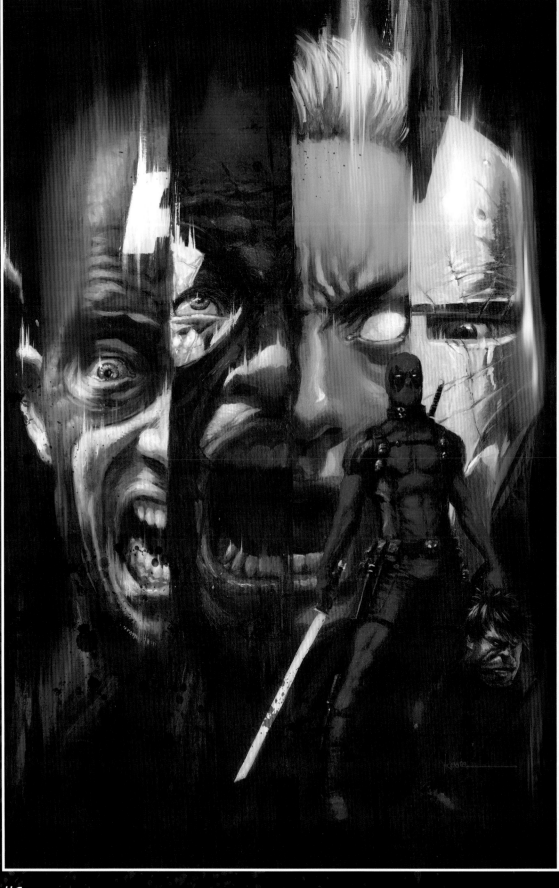

#1

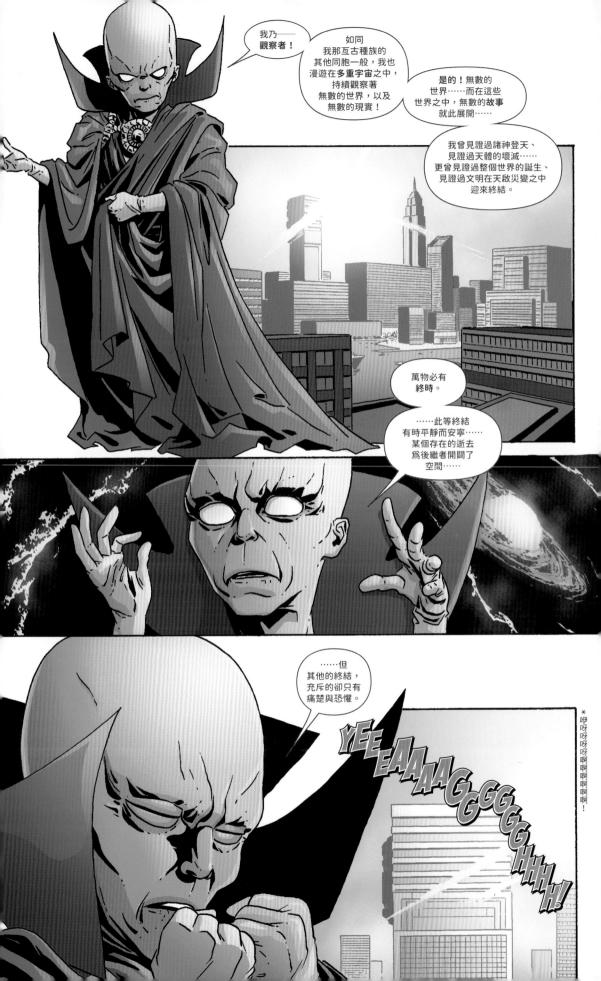

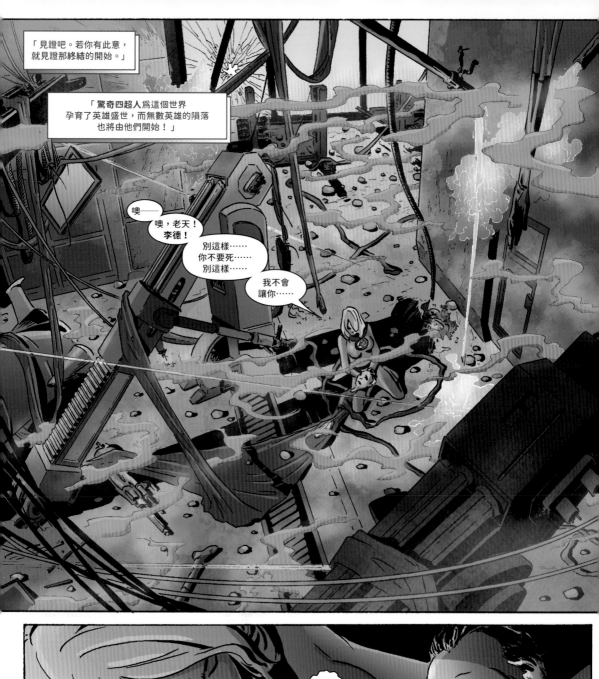
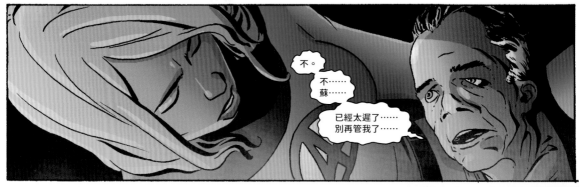

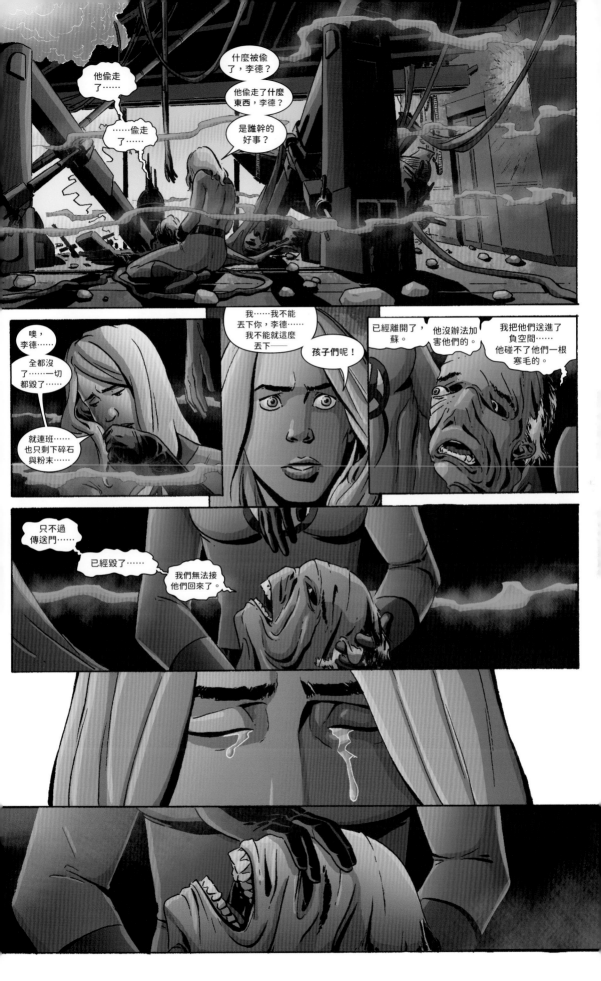

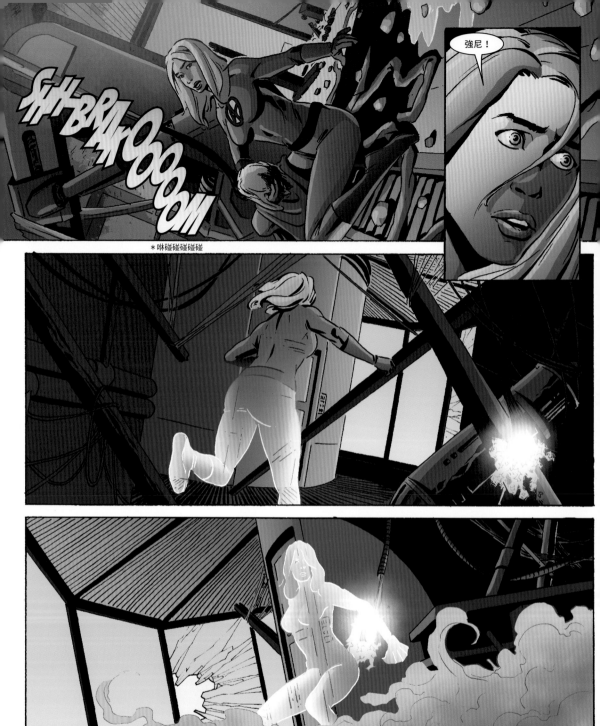

強尼！

*啉碰碰碰碰碰

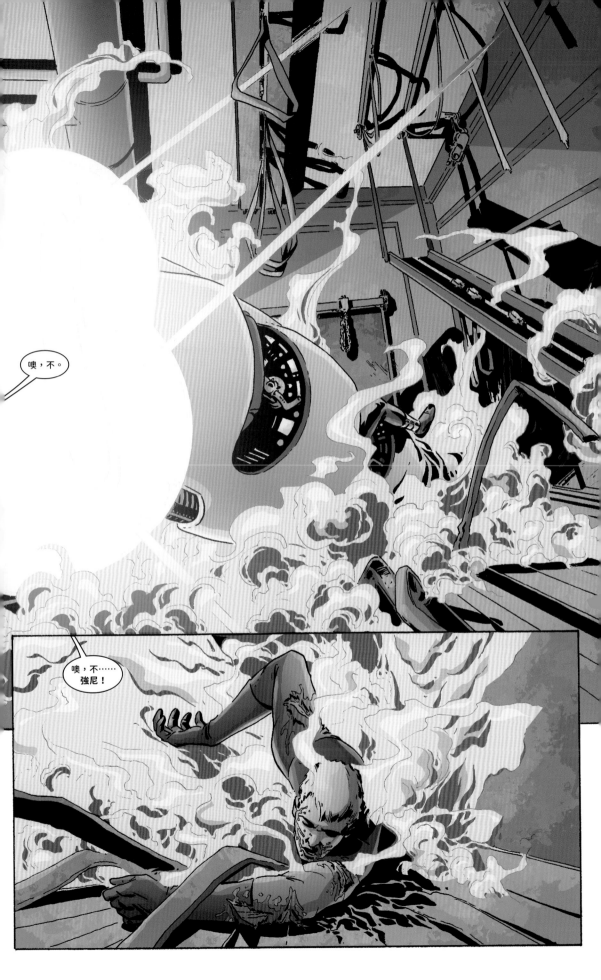

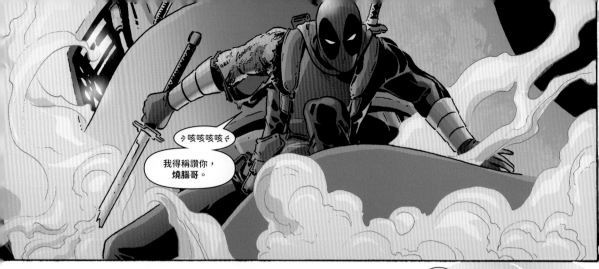

‹咳咳咳咳›

我得稱讚你，
燒腦哥。

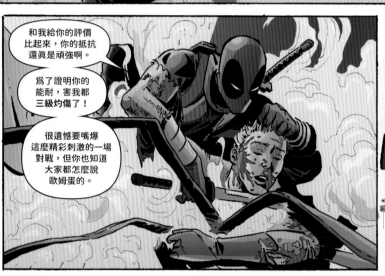

和我給你的評價
比起來，你的抵抗
還真是頑強啊。

為了證明你的
能耐，害我都
三級灼傷了！

很遺憾要嘴爆
這麼精彩刺激的一場
對戰，但你也知道
大家都怎麼說
歐姆蛋的。

......

*啊

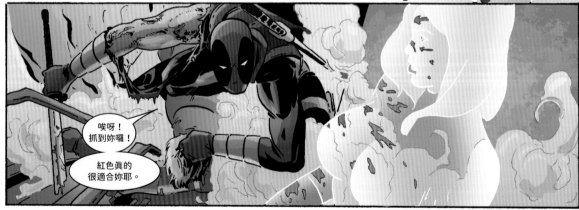

唉呀！
抓到妳囉！

紅色真的
很適合妳耶。

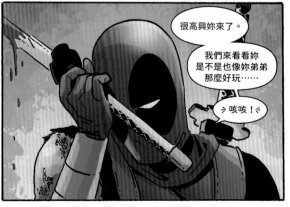

很高興妳來了。

我們來看看妳
是不是也像妳弟弟
那麼好玩……

‹咳咳！›

* 咿啊啊啊啊啊啊啊啊！

‹呃啊！›

REEEAAARRRGGHHH!

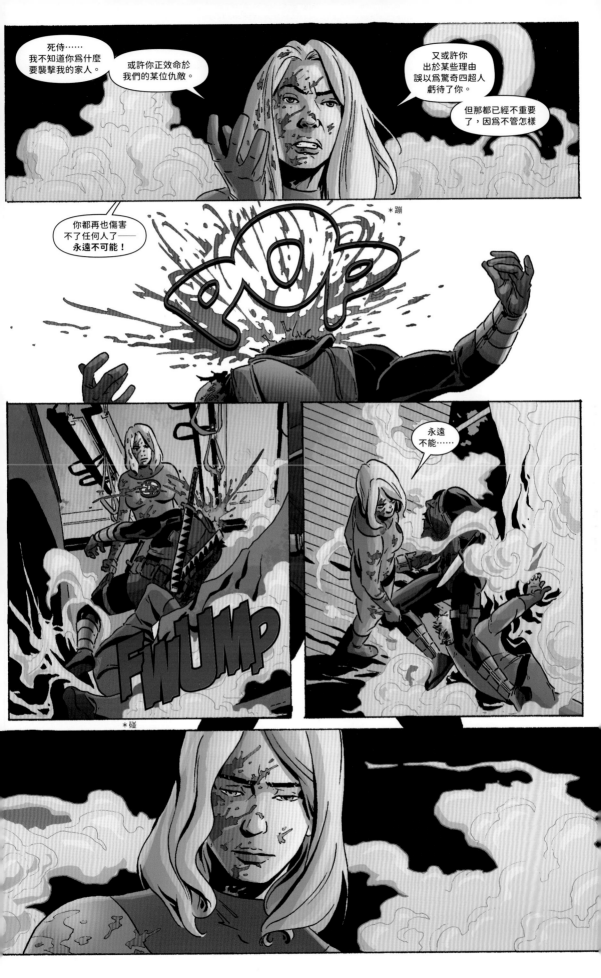

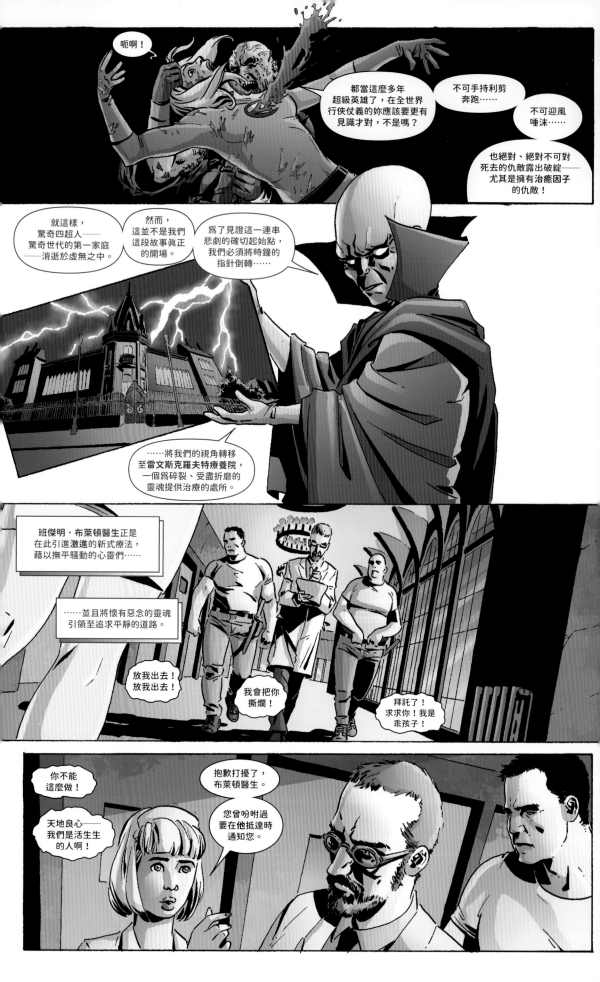

「他們把死侍送進來了。」

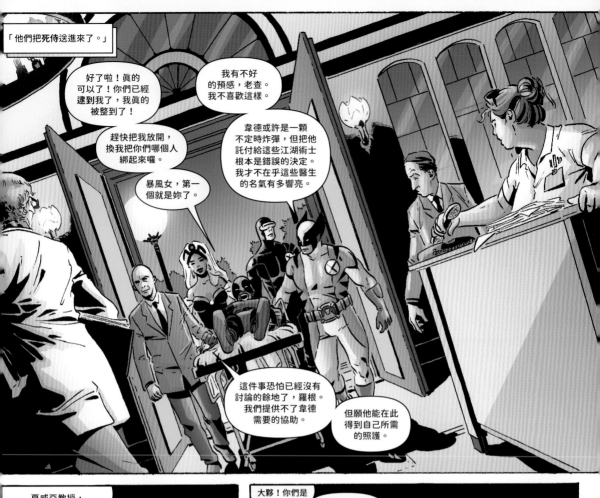

好了啦！真的可以了！你們已經逮到我了，我真的被整到了！

我有不好的預感，老查。我不喜歡這樣。

趕快把我放開，換我把你們哪個人綁起來囉。

韋德或許是一顆不定時炸彈，但把他託付給這些江湖術士根本是錯誤的決定。我才不在乎這些醫生的名氣有多響亮。

暴風女，第一個就是妳了。

這件事恐怕已經沒有討論的餘地了，羅根。我們提供不了韋德需要的協助。

但願他能在此得到自己所需的照護。

夏威亞教授，您大可放心。

雖然我採用的是非正統的療法，但我已經多次讓威爾森先生這樣的患者成功康復。

我也有自己的一套方法，布萊頓醫生。而我能向您保證——

您肯定會發現，死侍是一個獨一無二的案例。

大夥！你們是認真的嗎!?

我和這些醫療機構根本不對盤啊！

我有過好幾段無效的婚姻……

我的銀行戶頭透支……

我還放火燒毀過史密森尼學會……

嗯，我能理解您的意思。

但您大可放心。

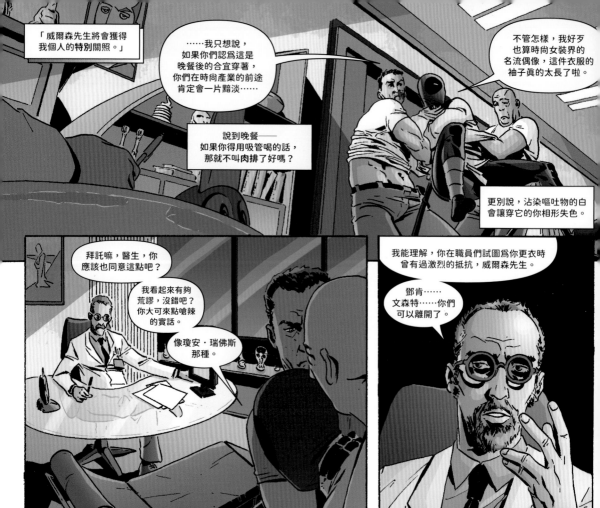

「威爾森先生將會獲得我個人的**特別**關照。」

……我只想說，如果你們認爲這是晚餐後的合宜穿著，你們在時尚產業的前途肯定會一片黯淡……

說到晚餐——如果你得用吸管喝的話，那就不叫肉排了好嗎？

不管怎樣，我好歹也算時尚女裝界的名流偶像，這件衣服的袖子眞的太長了啦。

更別說，沾染嘔吐物的白會讓穿它的你相形失色。

拜託嘛，醫生，你應該也同意這點吧？

我看起來有夠荒謬，沒錯吧？你大可來點嗆辣的實話。

像瓊安·瑞佛斯那種。

我能理解，你在職員們試圖爲你更衣時會有過激烈的抵抗，威爾森先生。

鄧肯……文森特……你們可以離開了。

晚點見囉，孩子們。

請自便，威爾森先生。

坐吧，讓我們好好瞭解一下彼此。

看來他想和我當個好麻吉。

你的意思是，我得向你傾訴自己的童年，然後盯著各種墨跡圖之類的嗎？

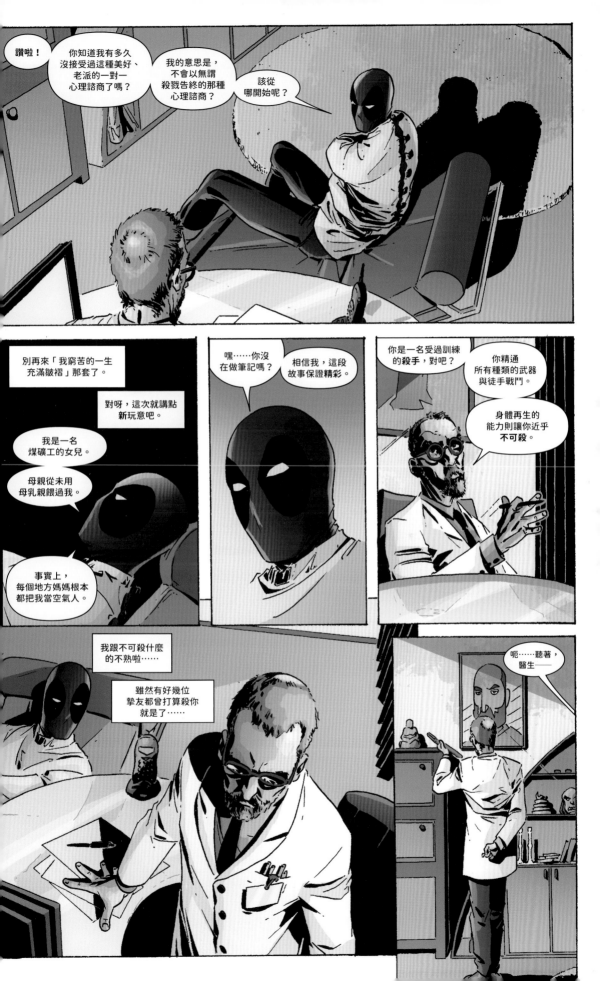

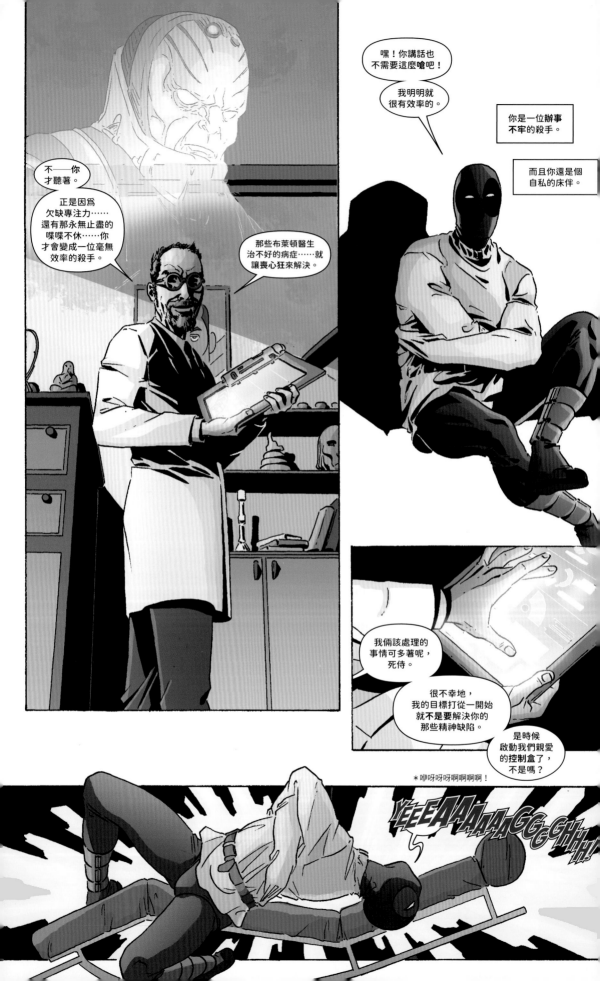

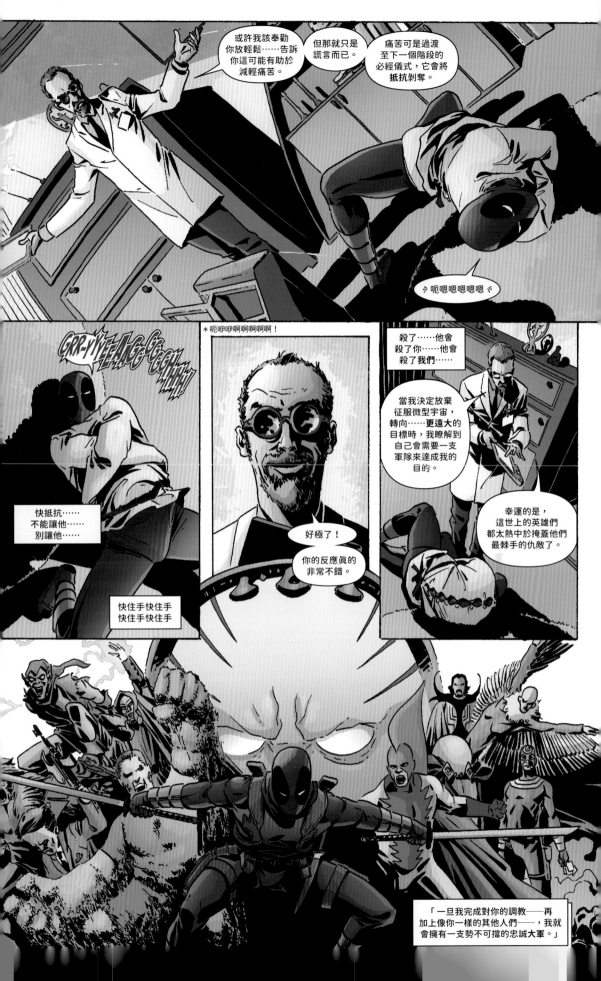

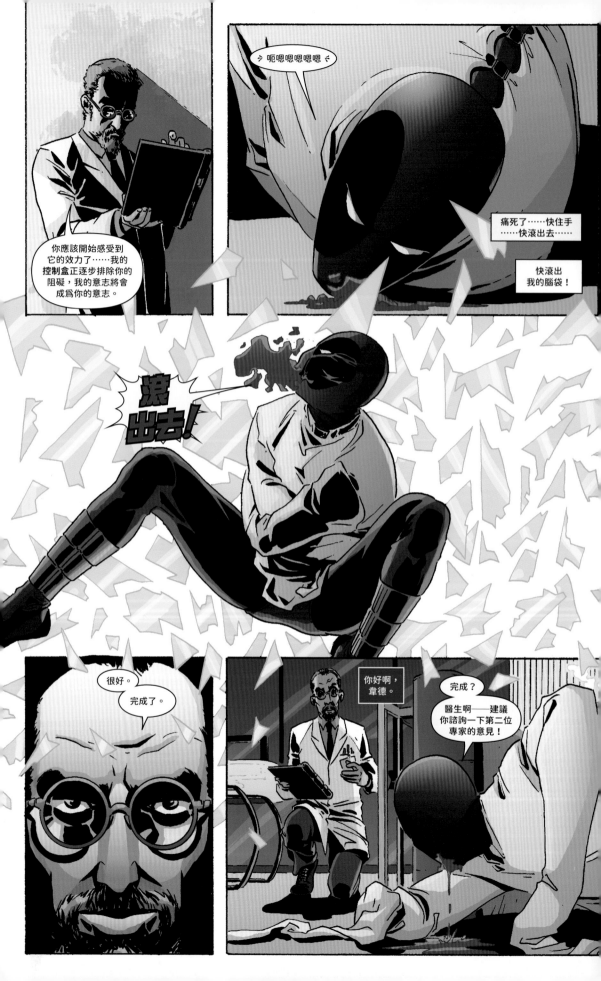

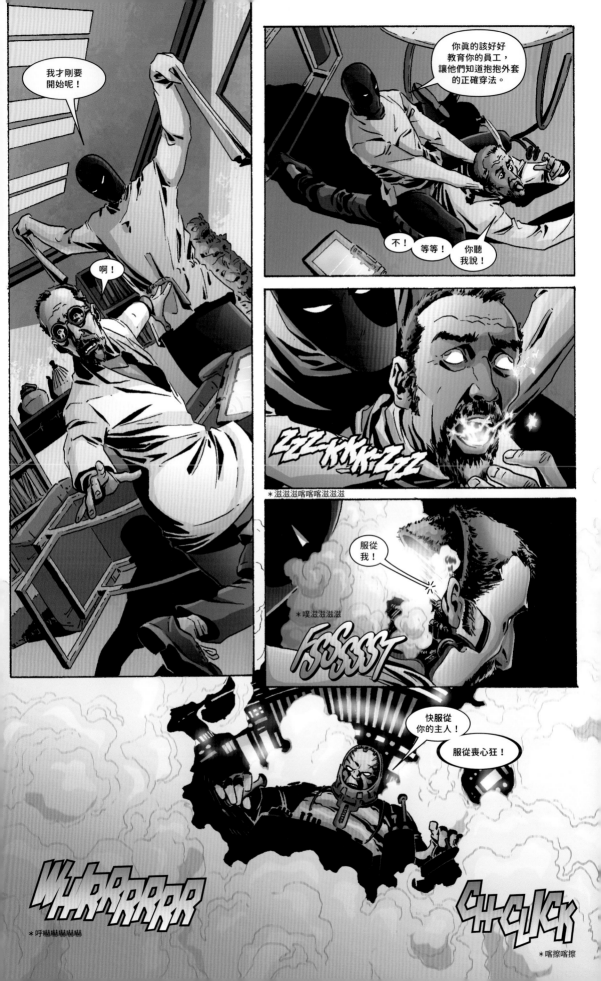

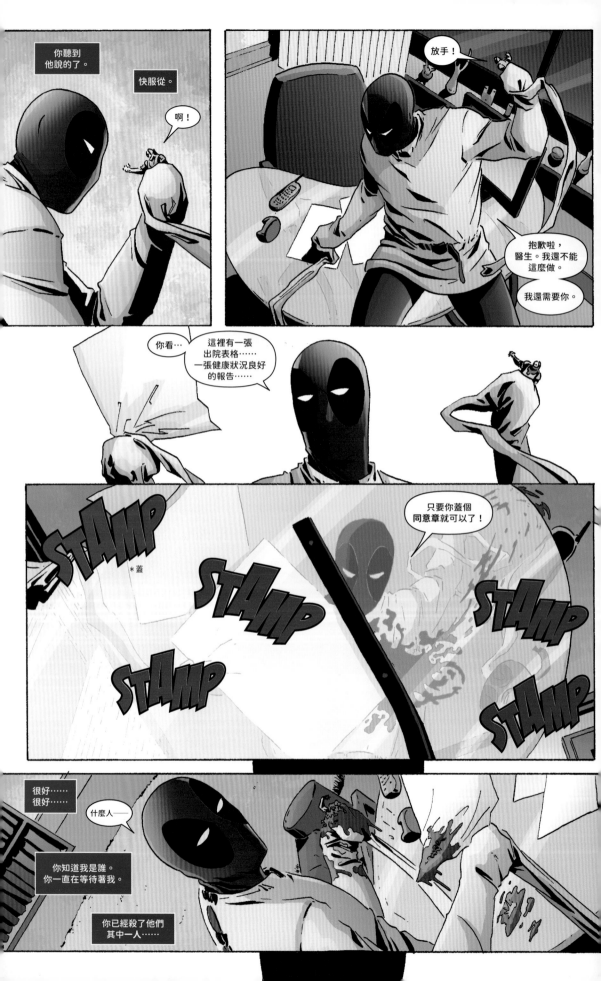

一不做二不休。

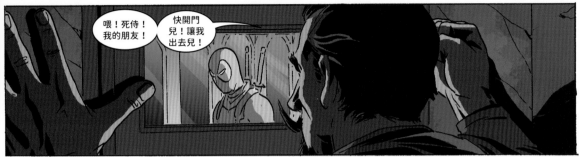

喂！死侍！我的朋友！

快開門兒！讓我出去兒！

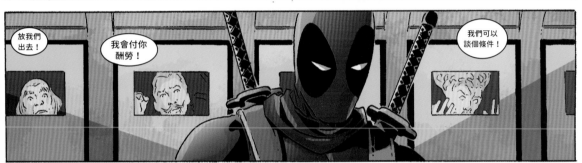

放我們出去！

我會付你酬勞！

我們可以談個條件！

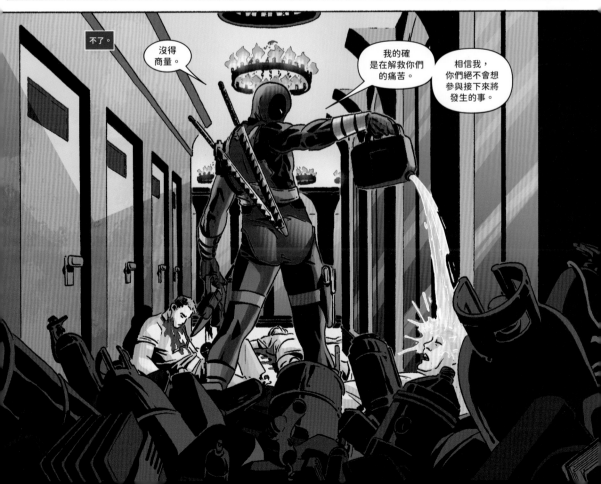

不了。

沒得商量。

我的確是在解救你們的痛苦。

相信我，你們絕不會想參與接下來將發生的事。

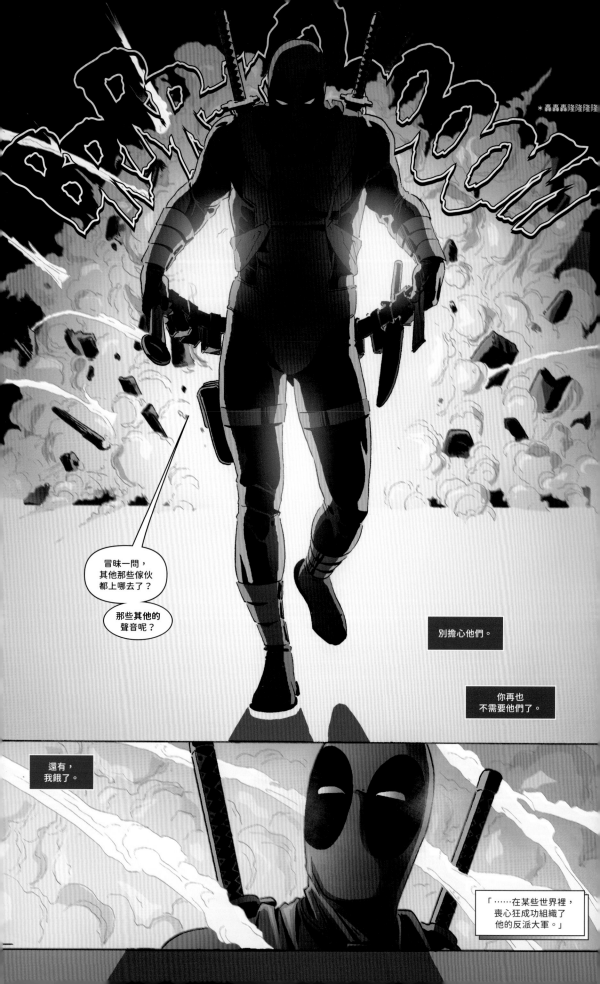

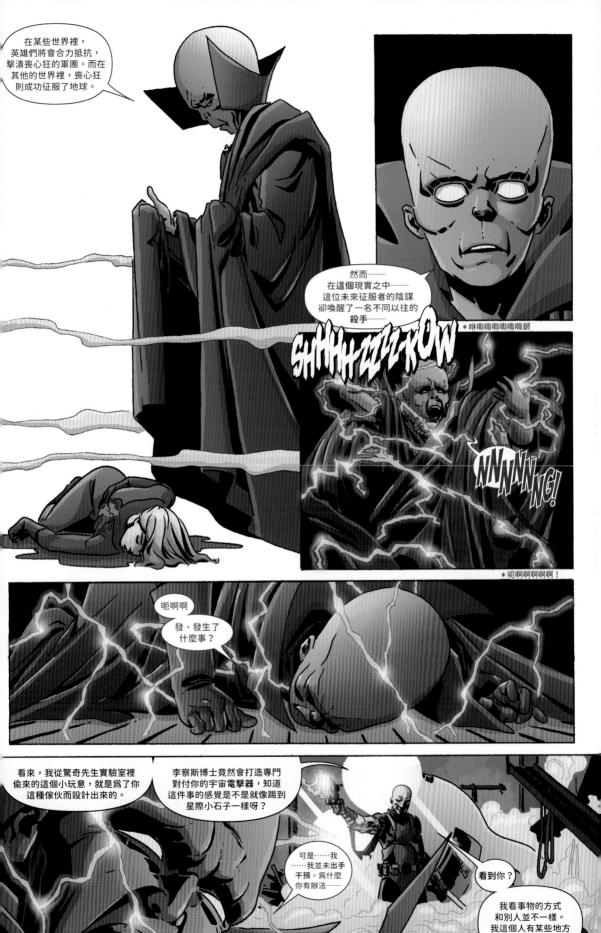

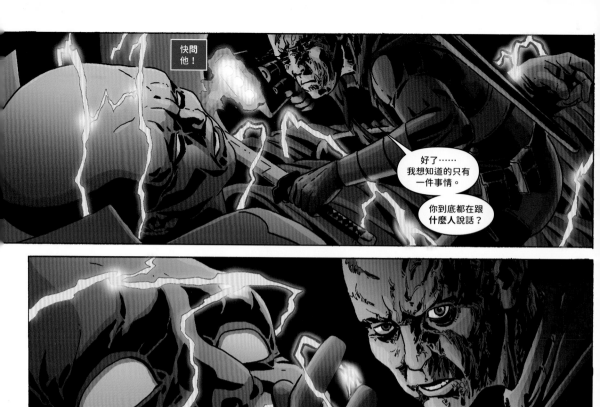

快問他！

好了……
我想知道的只有
一件事情。

你到底都在跟
什麼人說話？

噢一
噢。

好吧，
不管他們是誰——
這些居住在夢幻島的
小小偷窺狂們——
他們肯定會繼續
窺看下去的。

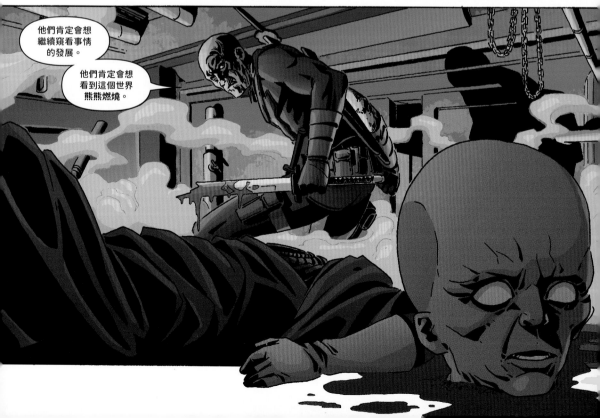

他們肯定會想
繼續窺看事情
的發展。

他們肯定會想
看到這個世界
熊熊燃燒。

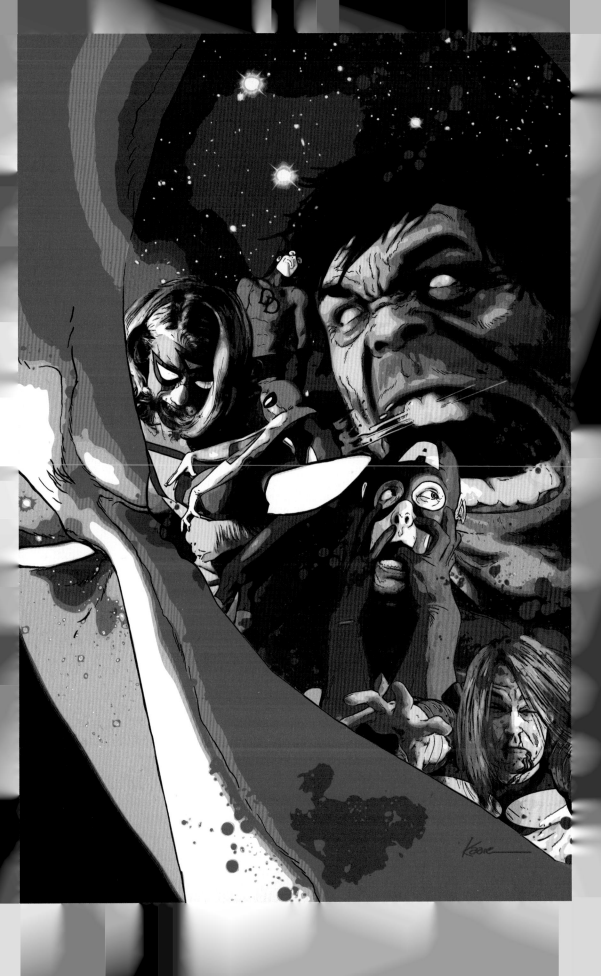

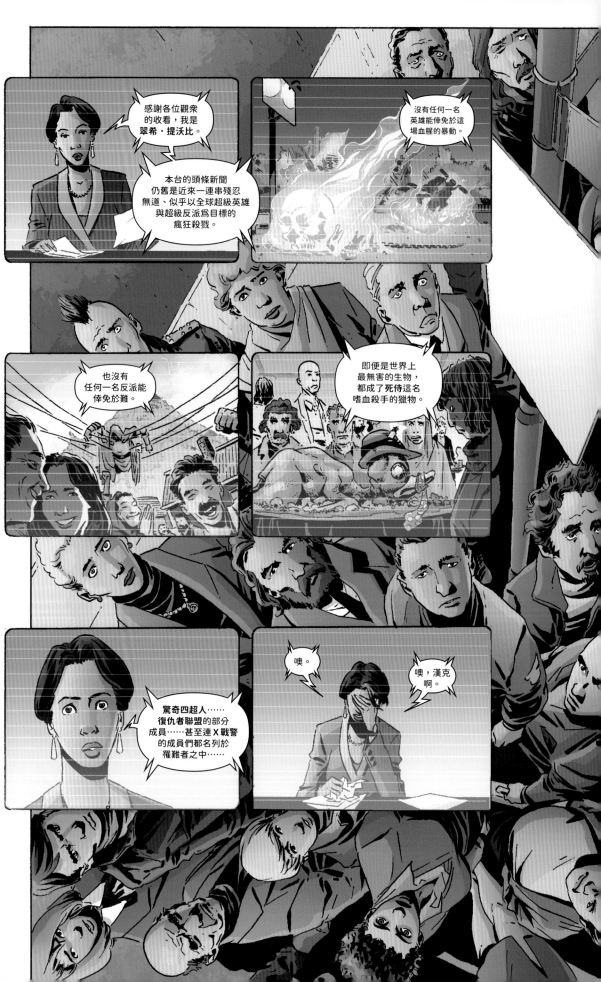

感謝各位觀眾的收看,我是翠希・提沃比。

本台的頭條新聞仍舊是近來一連串殘忍無道、似乎以全球超級英雄與超級反派為目標的瘋狂殺戮。

沒有任何一名英雄能倖免於這場血腥的暴動。

也沒有任何一名反派能倖免於難。

即便是世界上最無害的生物,都成了死侍這名嗜血殺手的獵物。

驚奇四超人……復仇者聯盟的部分成員……甚至連X戰警的成員們都名列於罹難者之中……

噢。

噢,漢克啊。

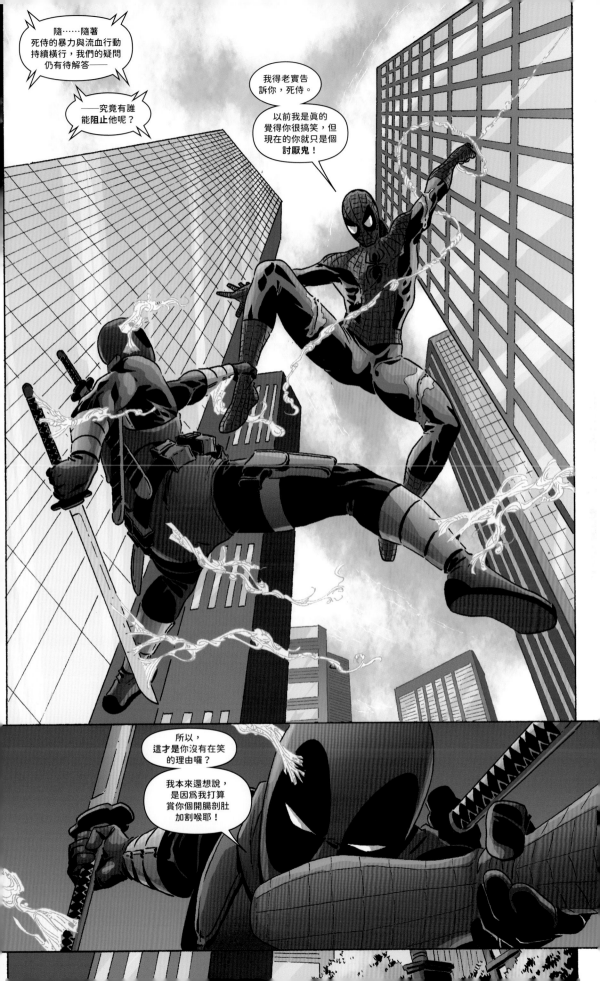

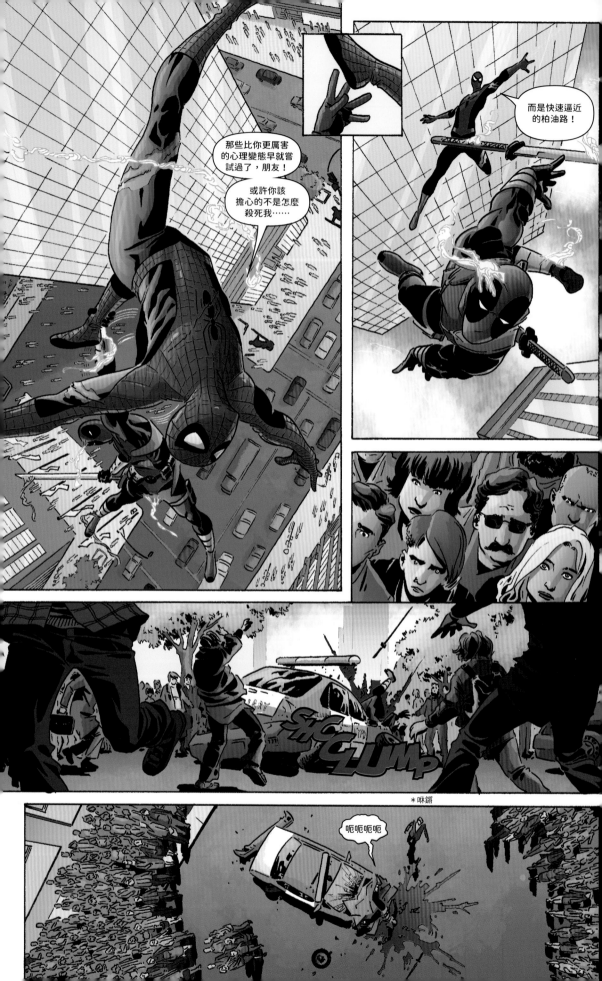

*咔鏘

呃呃呃呃

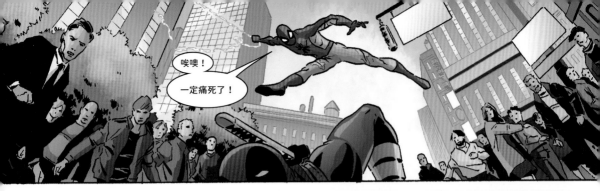

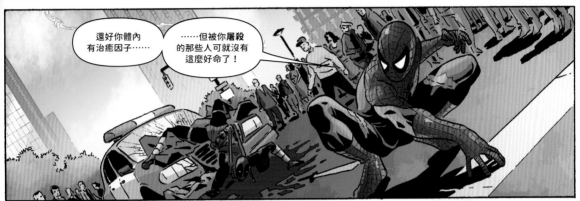

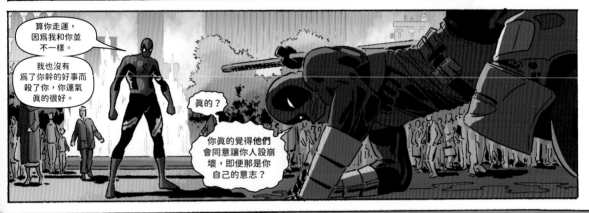

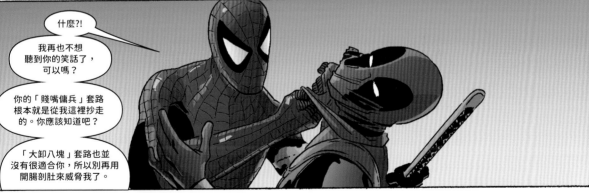

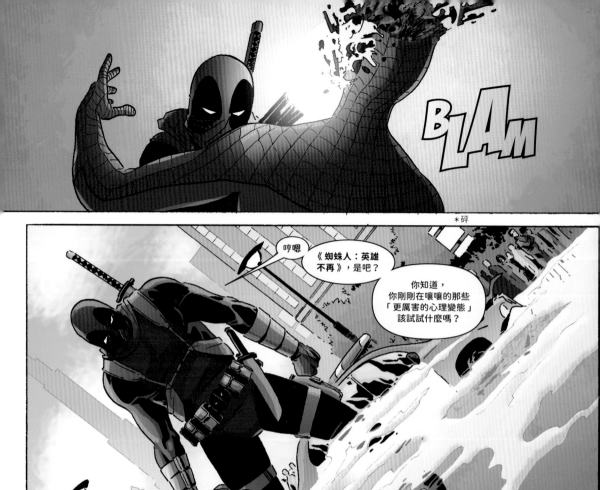

BLAM

*砰

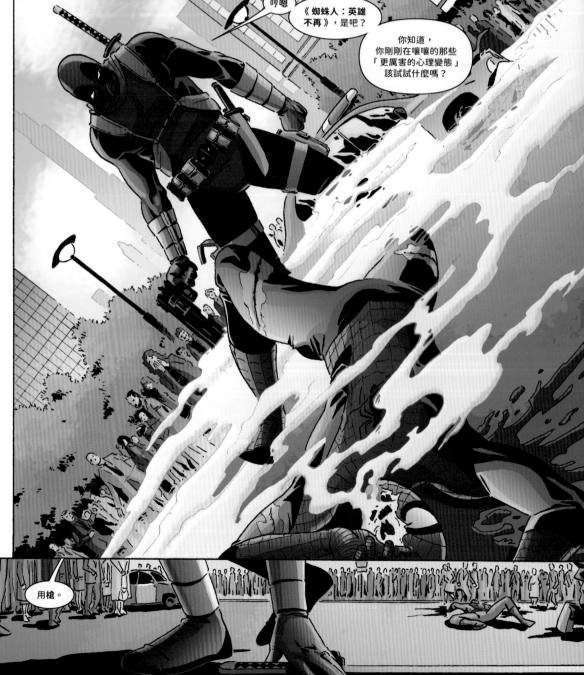

哼嗯 《蜘蛛人：英雄不再》，是吧？

你知道，你剛剛在嚷嚷的那些「更厲害的心理變態」該試試什麼嗎？

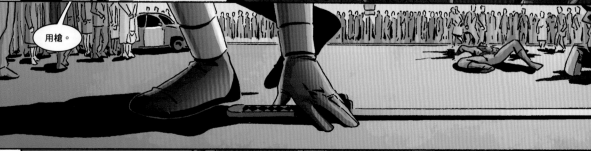

用槍。

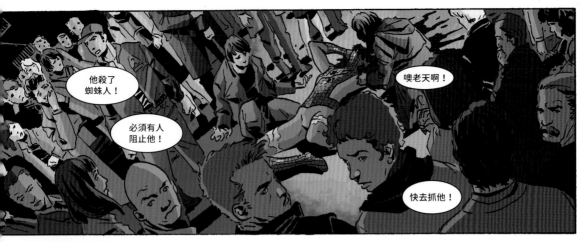

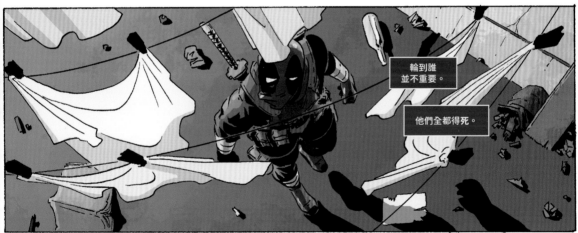

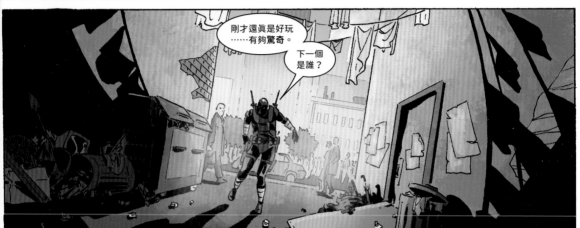

這太小家子氣了。

我要的是勁爆的演出。我要的是盛大的場面。

不。

*喀啦

這是以前那個死侍的想法。

你沒有必要取悅任何人。現在你有我了。

可是我一直都擁有你，不是嗎？

你一直都在。你埋伏在我的內心深處。

我想，這些年來不斷讓我從內腐敗至外的就是你吧。

別搞得太複雜。

KR-CHGK

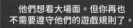

他們想看大場面。但你再也不需要遵守他們的遊戲規則了。

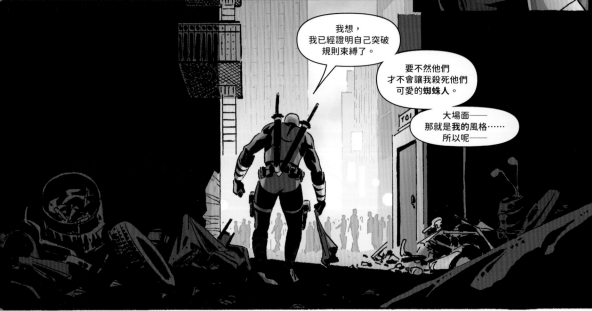

我想，我已經證明自己突破規則束縛了。

要不然他們才不會讓我殺死他們可愛的蜘蛛人。

大場面——那就是我的風格⋯⋯所以呢——

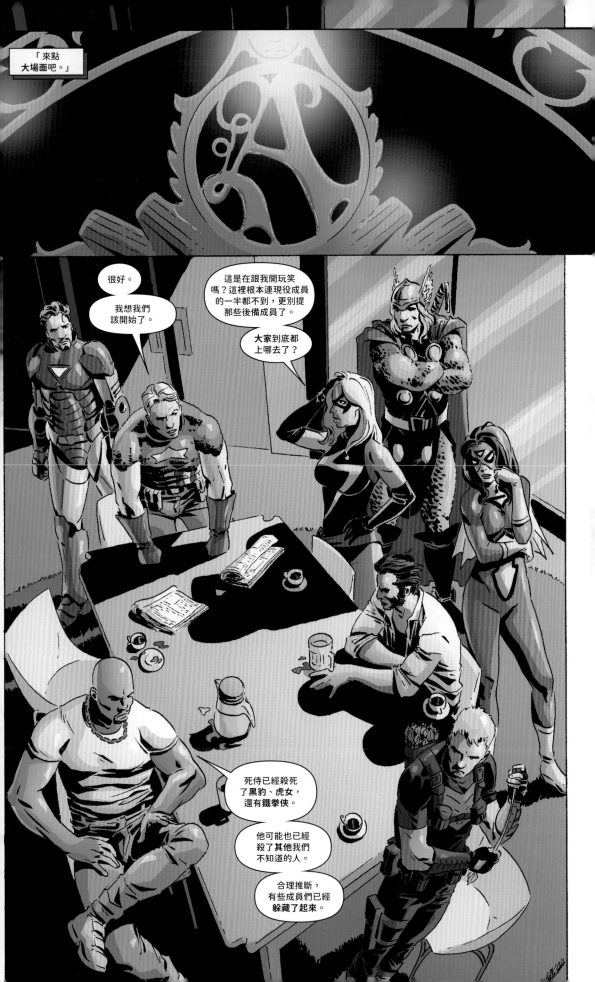

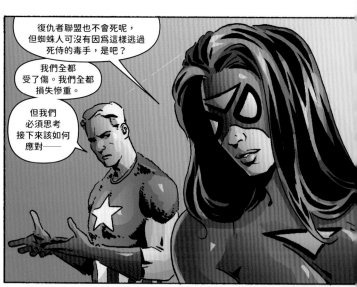
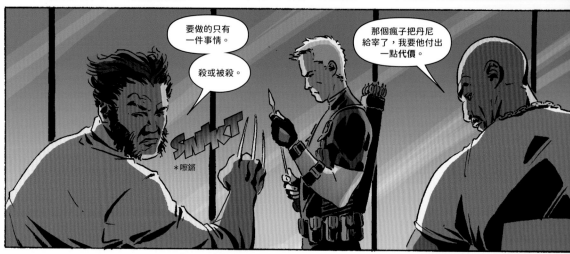
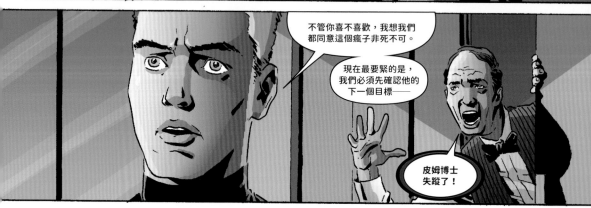
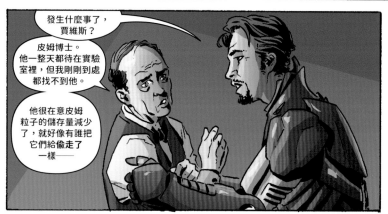
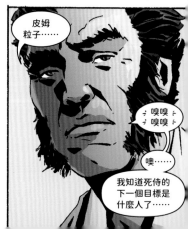

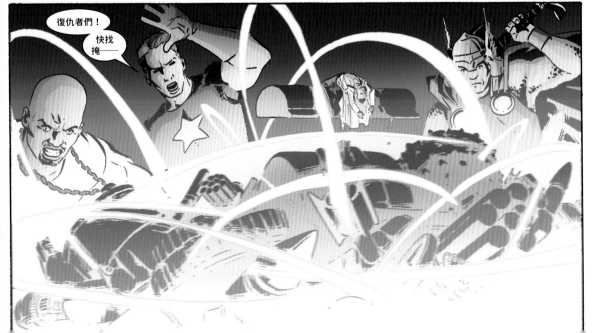

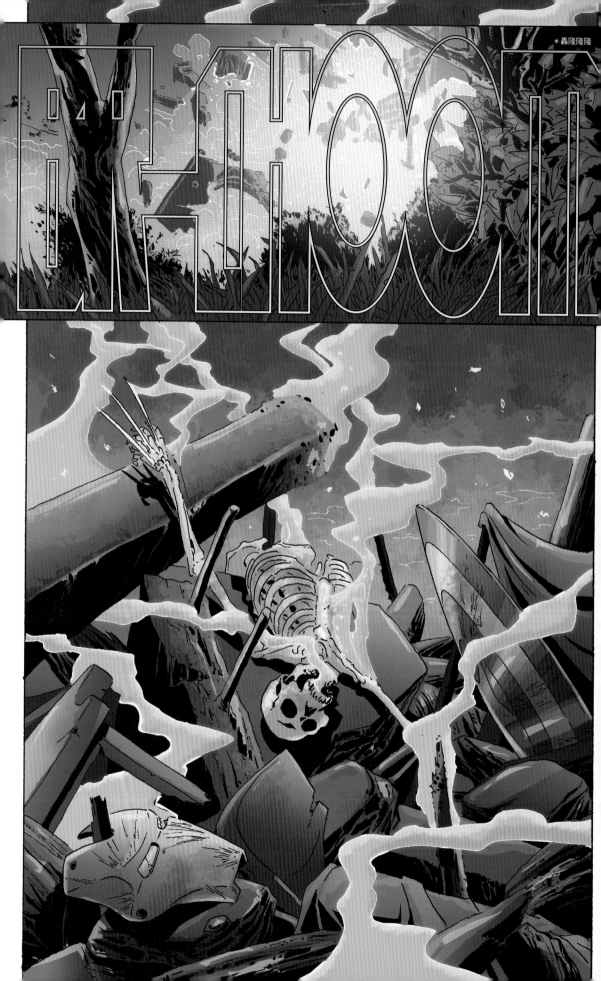

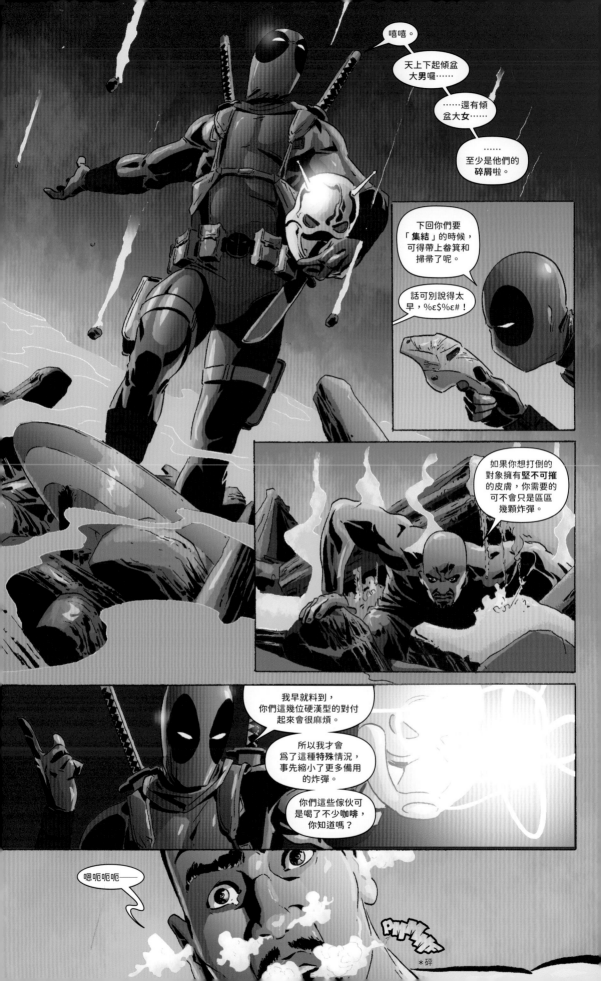

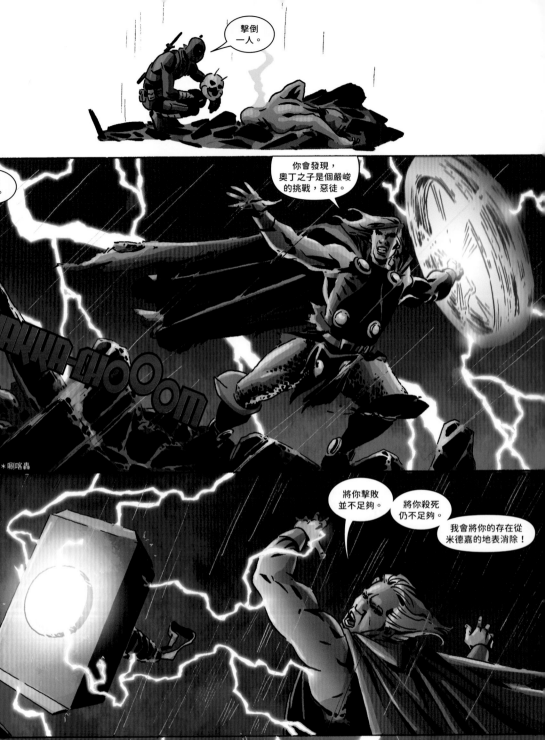

到底哪一邊
比較強?

是你的鏈子,
還是你的肉身?

以阿斯嘉
之名——

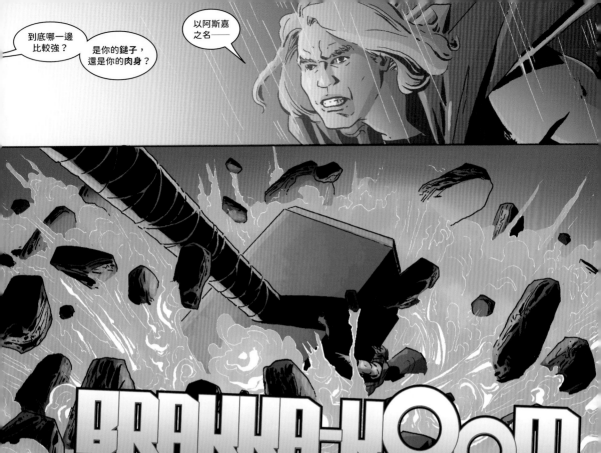

BRAKKA-KOOM

*磅喀砰

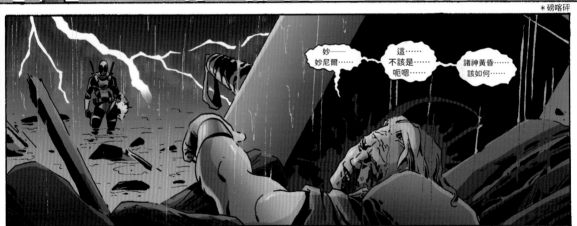

妙——
妙尼爾……

這……
不該是……
呃嗯……

諸神黃昏……
該如何……

我還能
說什麼呢?
汝納命來。

嘿嘿。

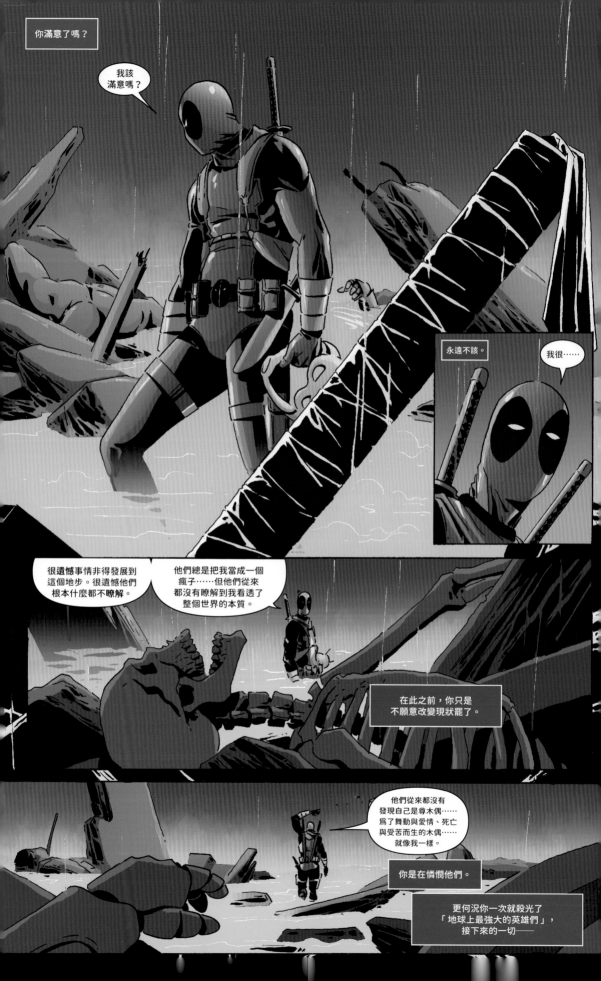

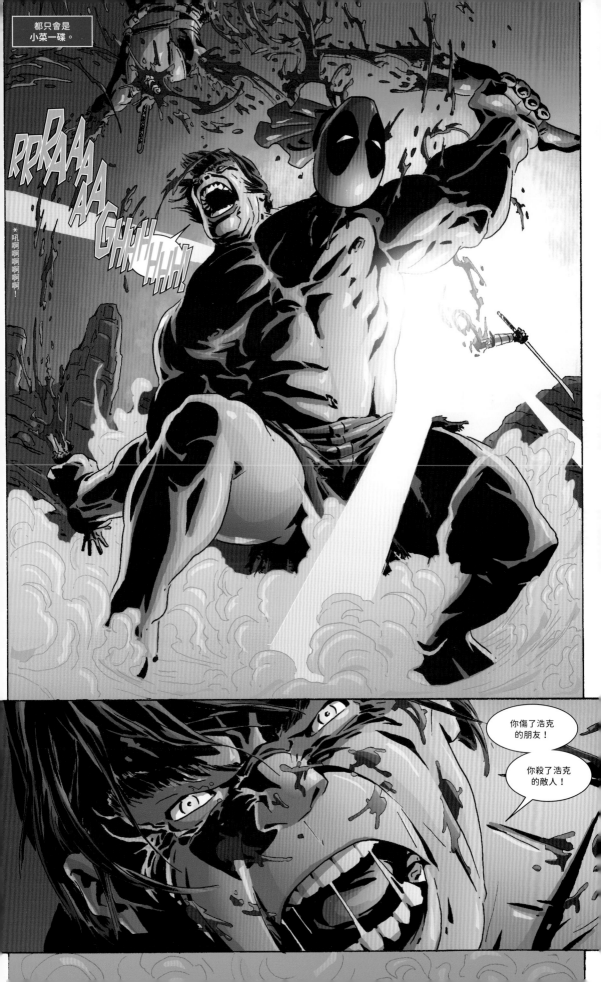

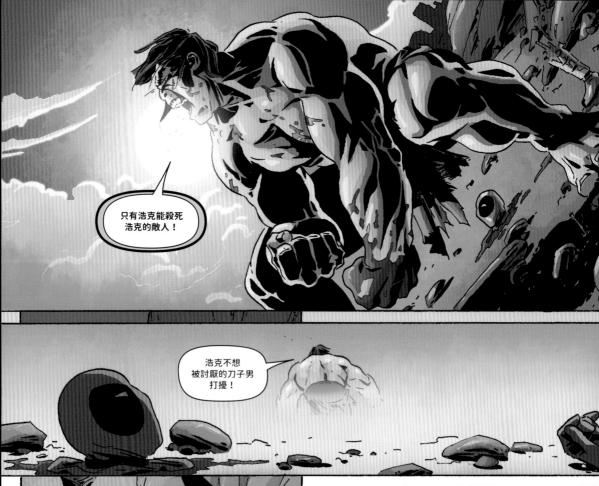

只有浩克能殺死
浩克的敵人！

浩克不想
被討厭的刀子男
打擾！

浩克只想
一個人靜一靜。

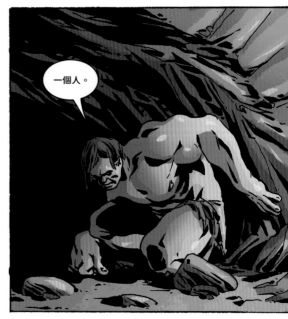

一個人。

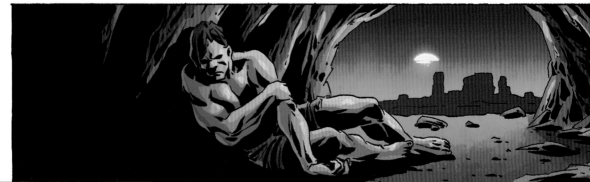

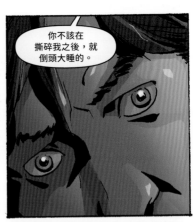
你不該在撕碎我之後，就倒頭大睡的。

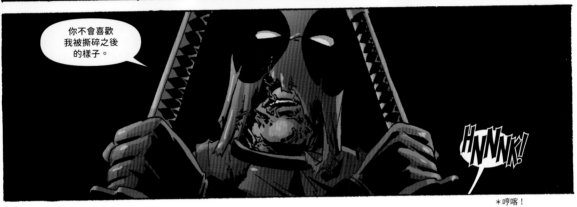
你不會喜歡我被撕碎之後的樣子。

HNNNK!

＊哼喀！

ZSSSSH

＊嘶喇

蜘蛛人、復仇者聯盟，還有浩克。

不過短短數日，這工作成果還真是不錯。

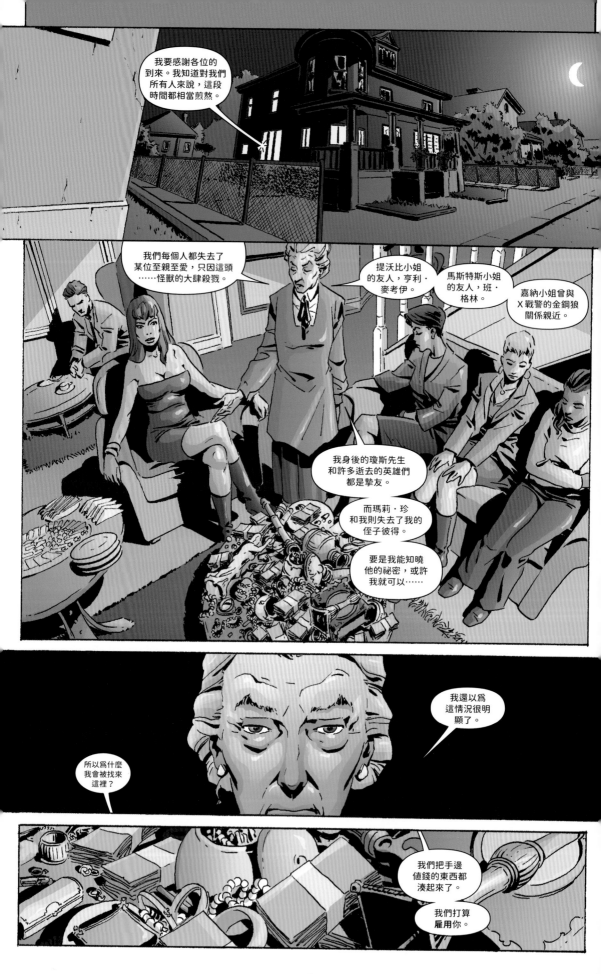

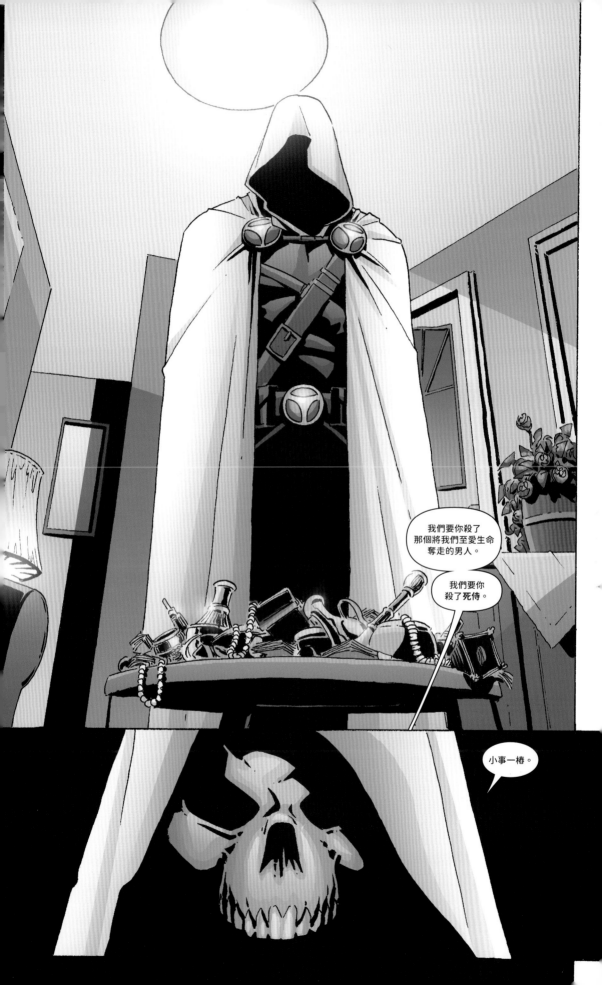

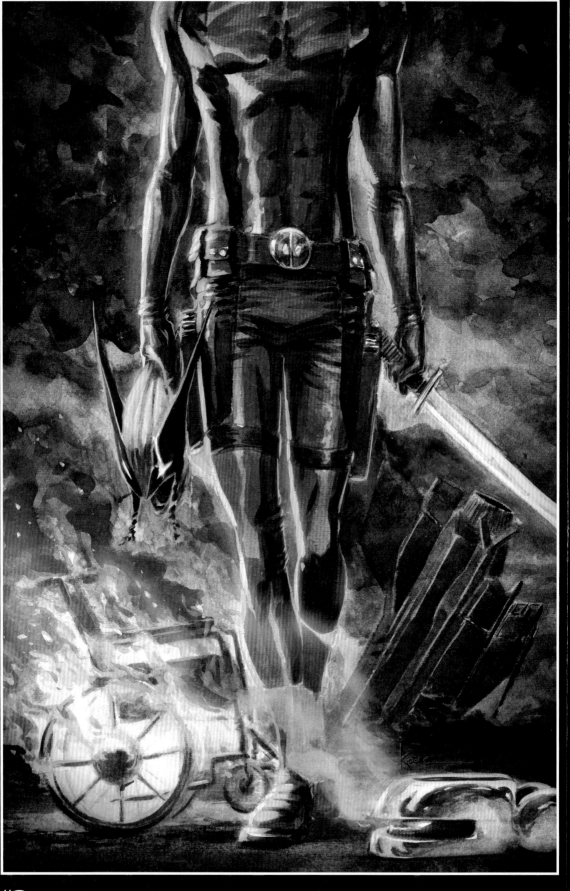

\#3

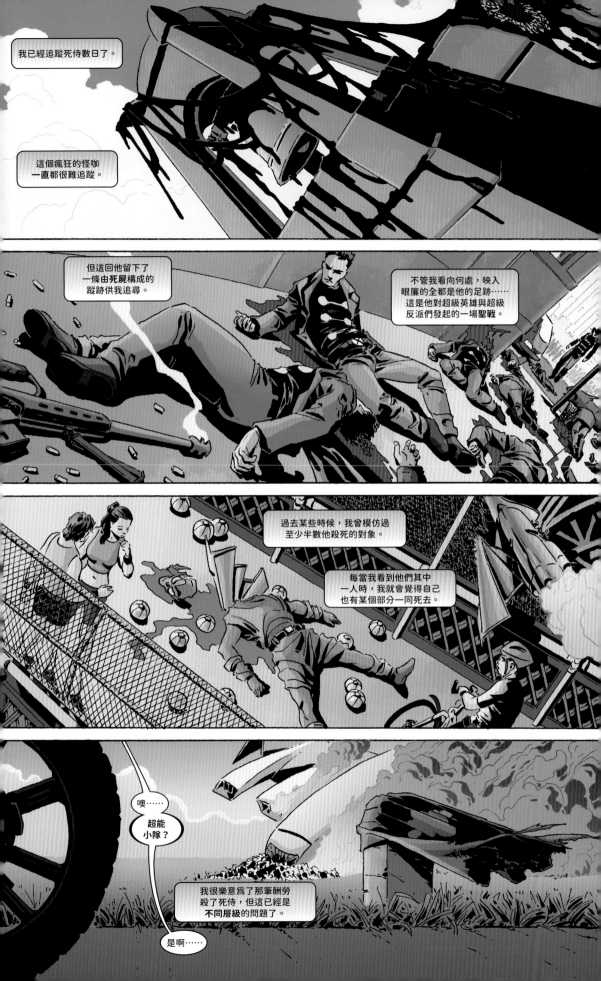

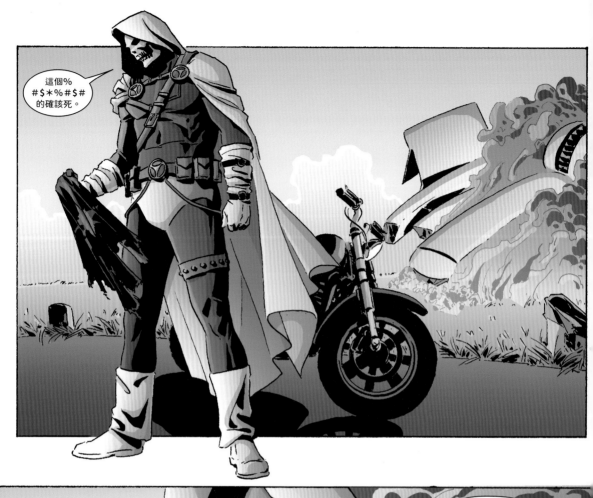

起床囉，禿頭。

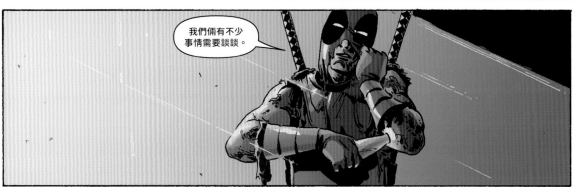

我們倆有不少事情需要談談。

等你死了之後，就能一次睡個飽囉。

然後——相信我——你不會需要等待多久的。

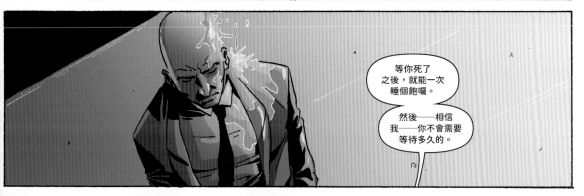

還有⋯⋯如果現在就失去意識的話，你可是會錯過節目最精采的部分喔！

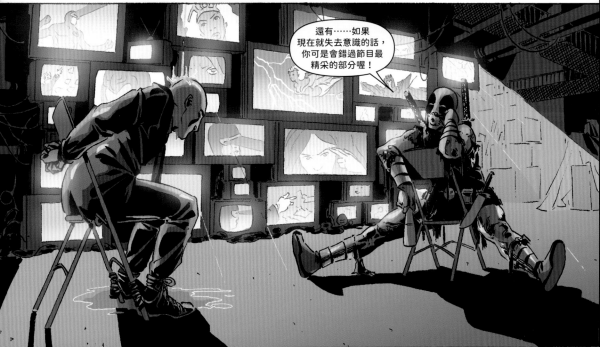

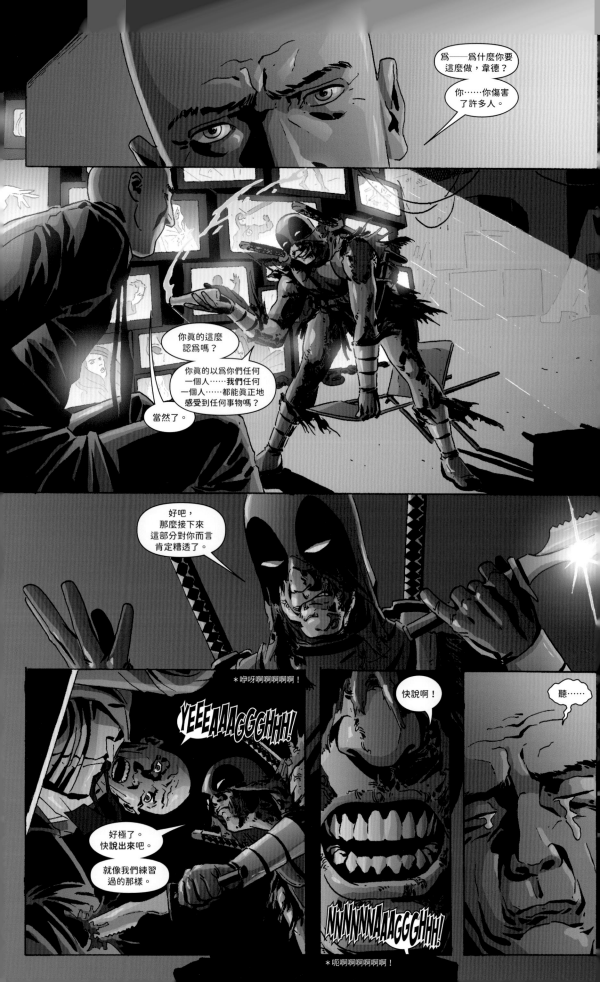

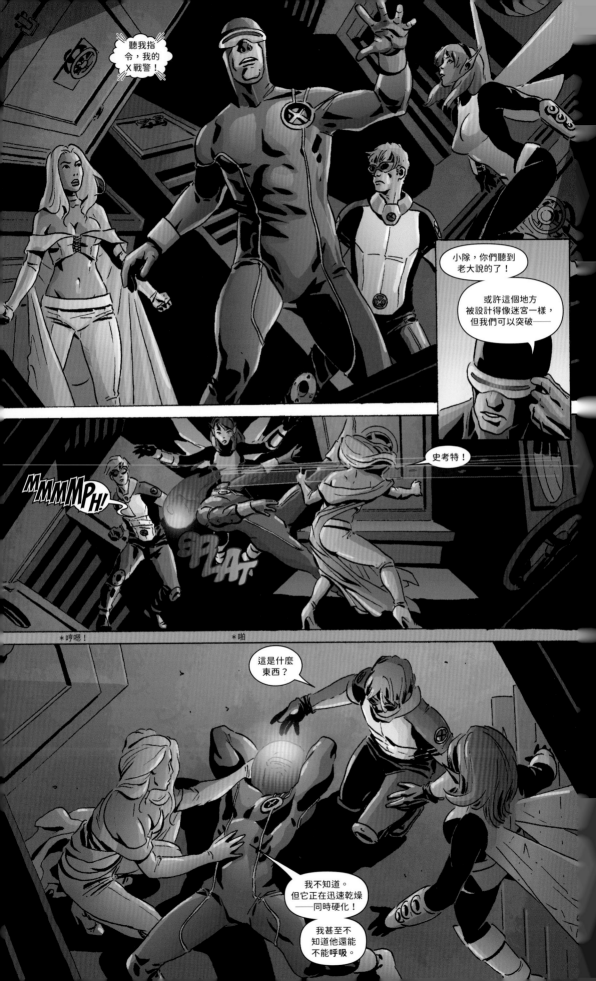

小精靈！
我必須讓他脫離這裡！給他一點——

我想他正打算把這東西轟開……

山姆…

不要！
小心——

＊啊啊啊啊！

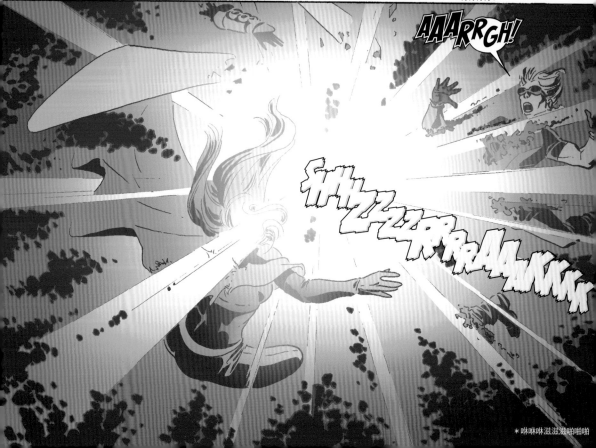

AAARRGH!

SHHZZ-ZZRRRAAANKKK

＊咻咻咻滋滋滋啪啪啪

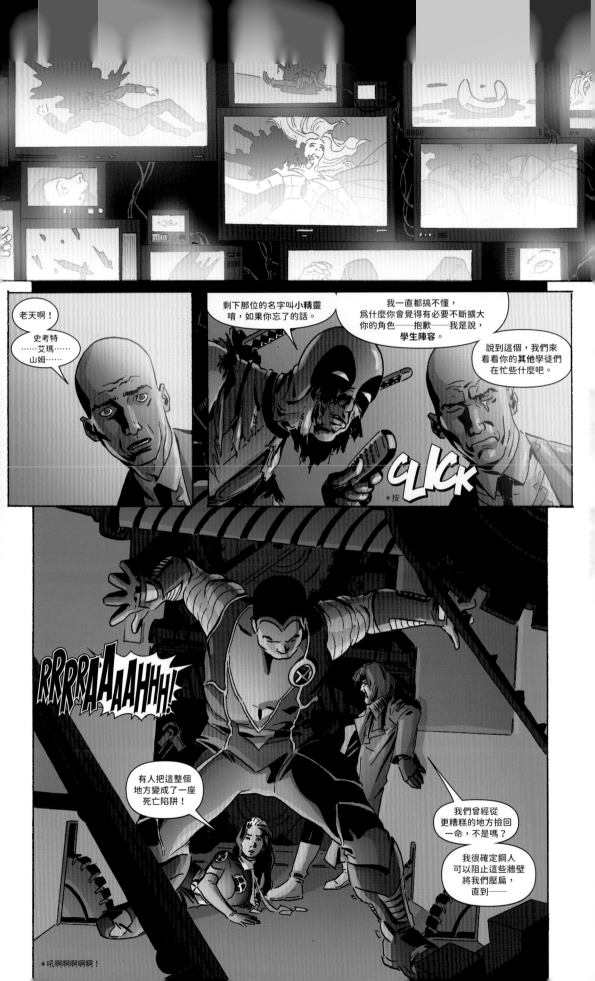

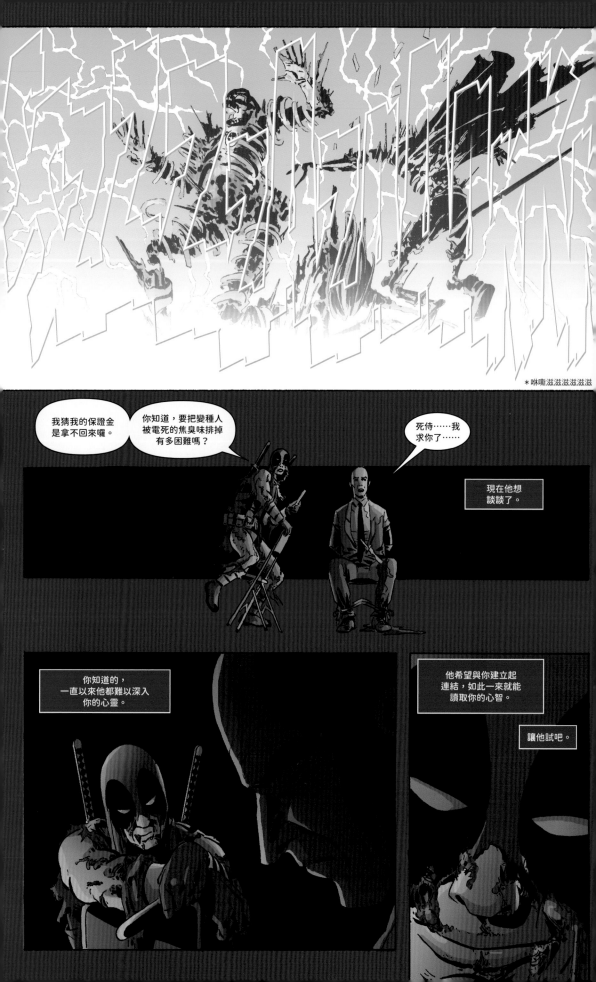

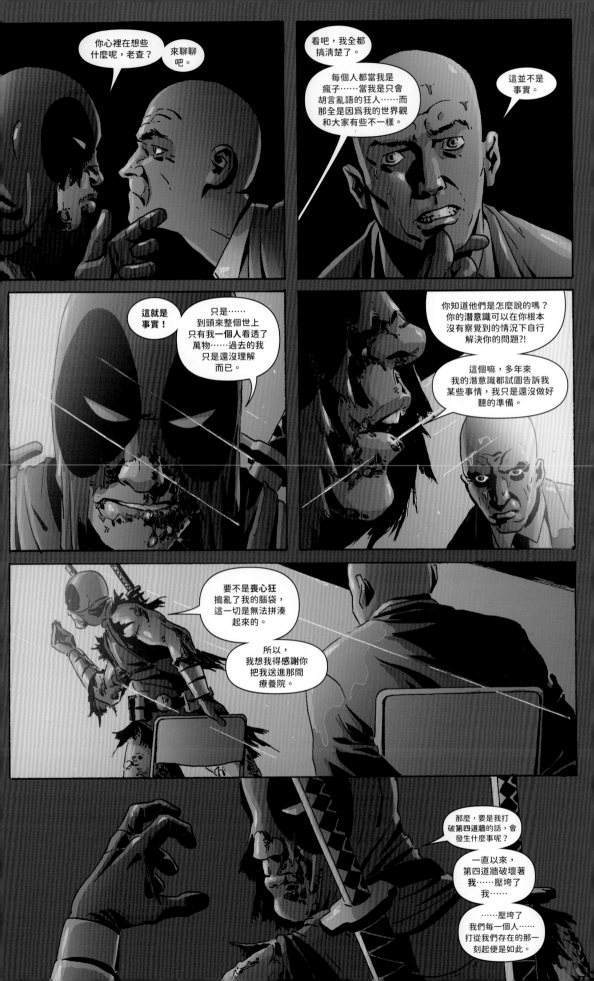

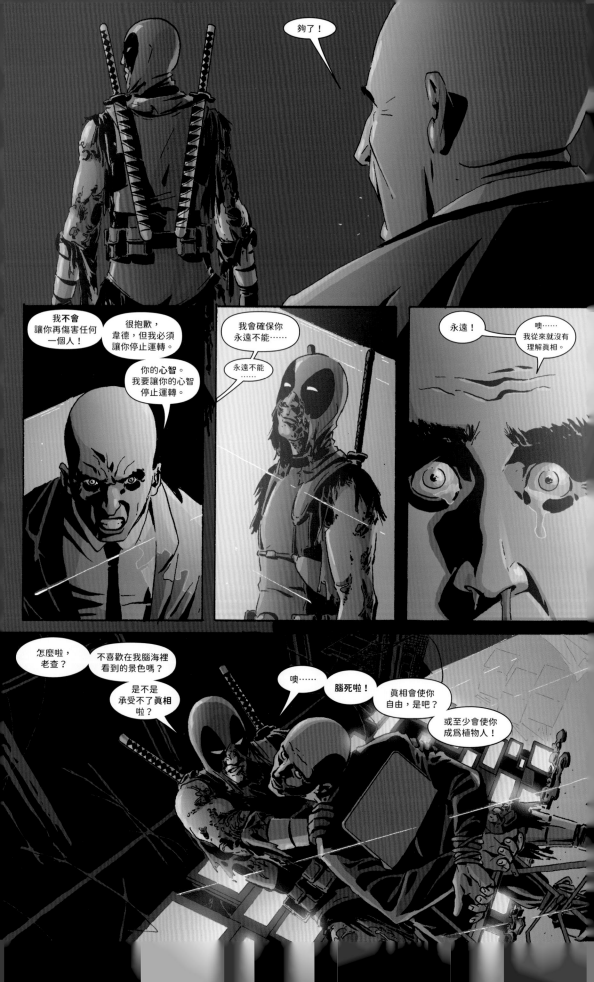

「祝妳早日找到逃出蟑螂屋的方法，小甜心！」

「我其實不太懂物理學或立方體之類的東西，但我對倉鼠滾輪還有遊樂園的鏡像迷宮可是熟到不行呢！小貓咪是逃不出來的。」

「永恆的囚禁和殺戮的效果是一樣的，我猜。」

「先等一下！」

「這是怎麼回事？」

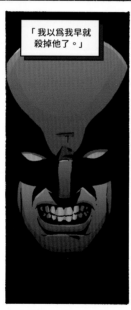

「我以為我早就殺掉他了。」

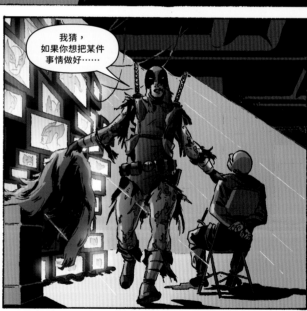

我猜，如果你想把某件事情做好……

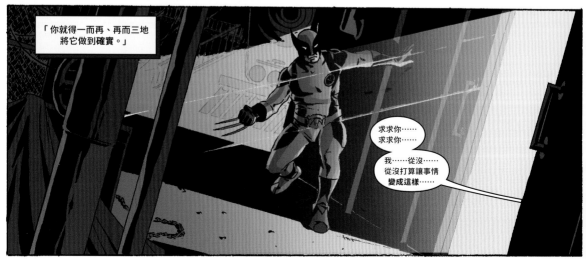

「你就得一而再、再而三地將它做到確實。」

求求你……
求求你……

我……從沒……從沒打算讓事情變成這樣……

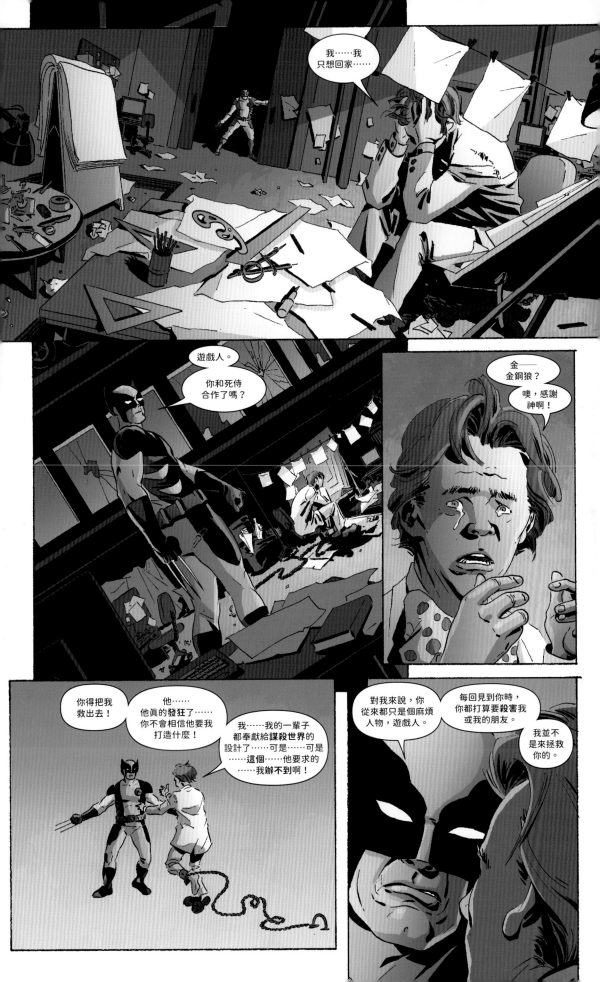

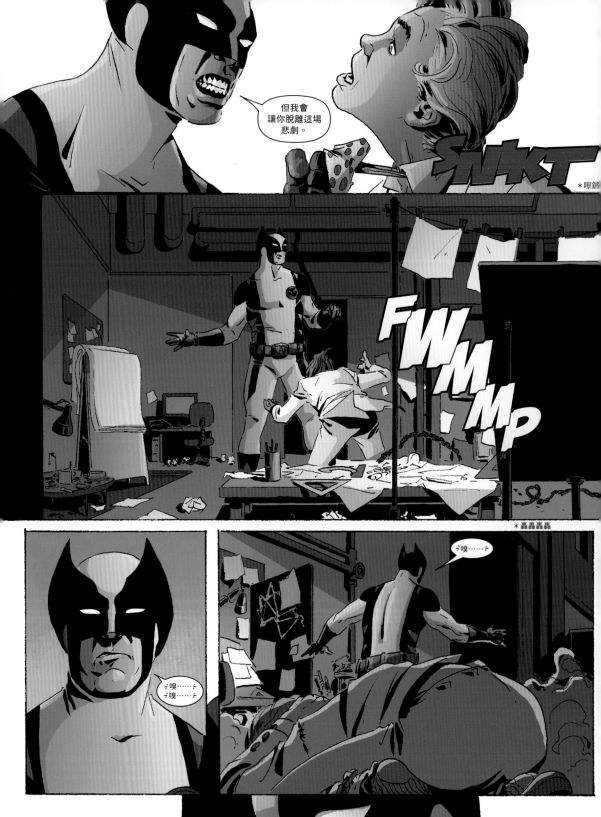

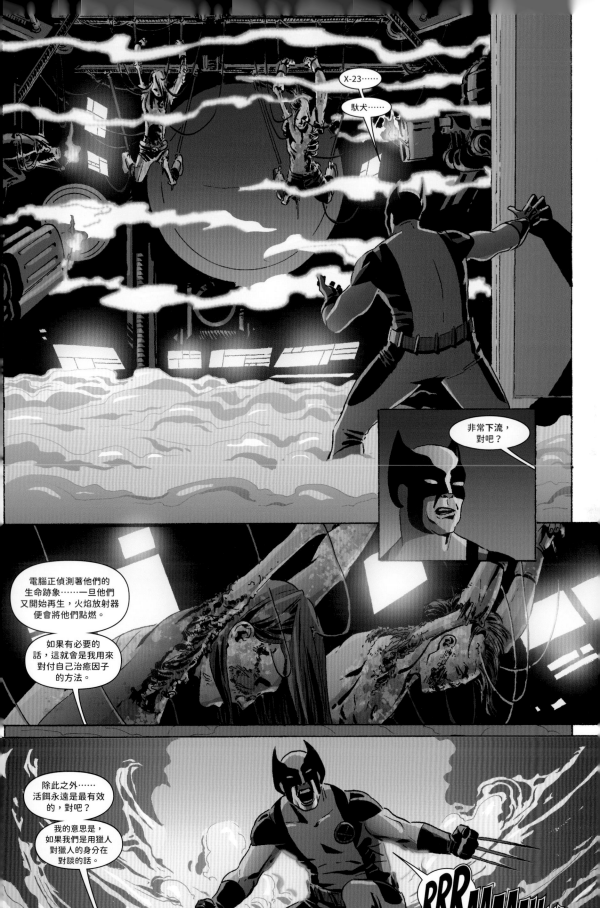

*吼啊啊啊啊啊！

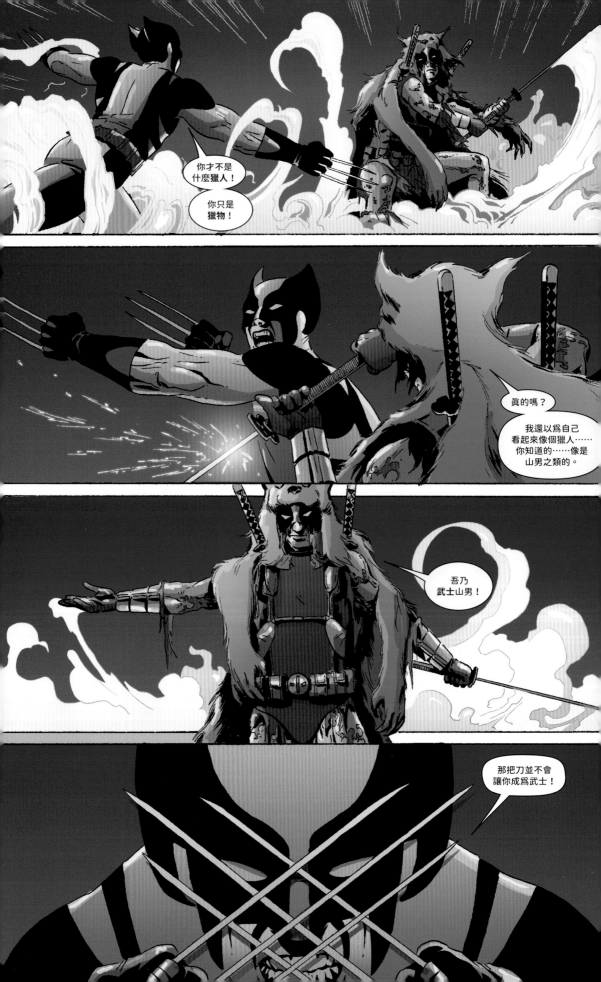

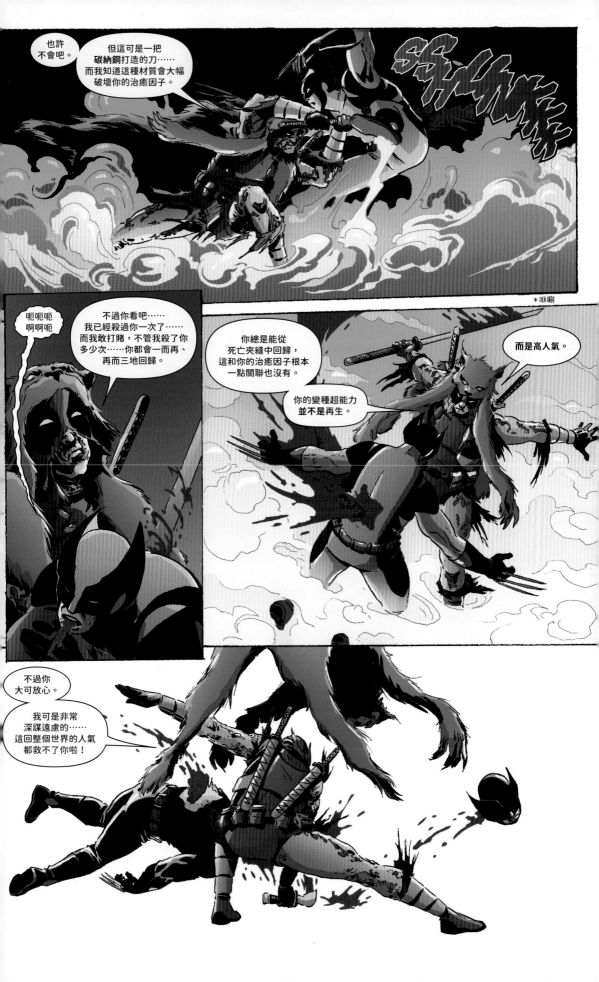

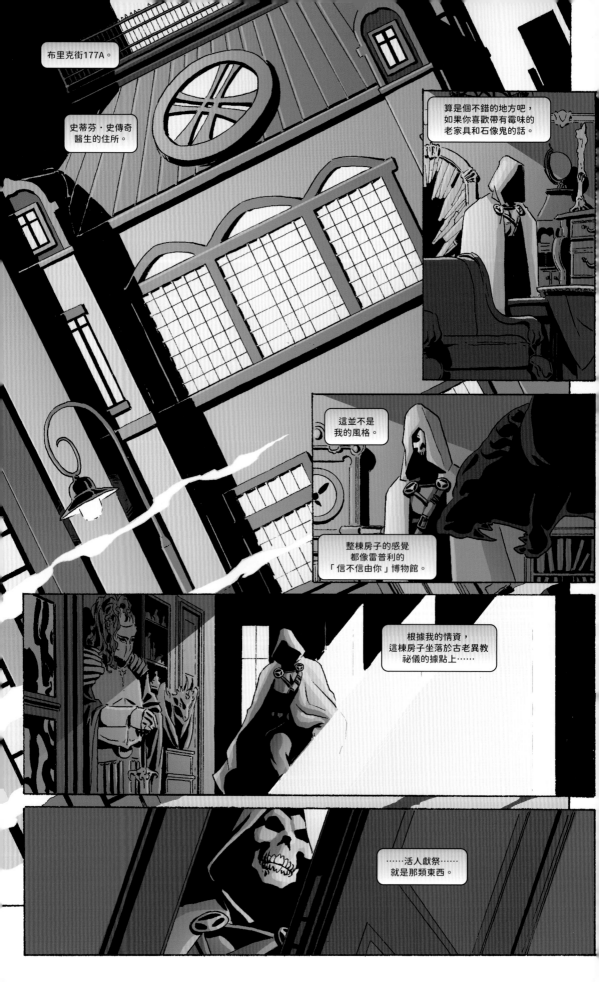

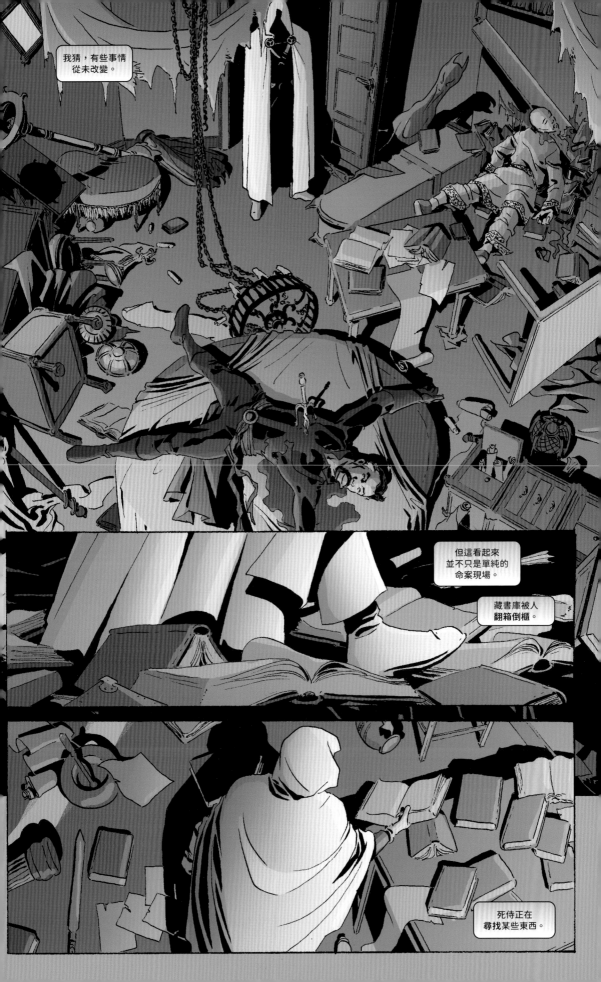

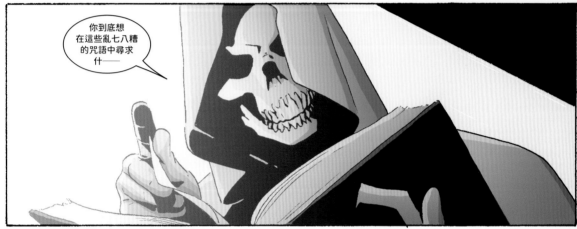

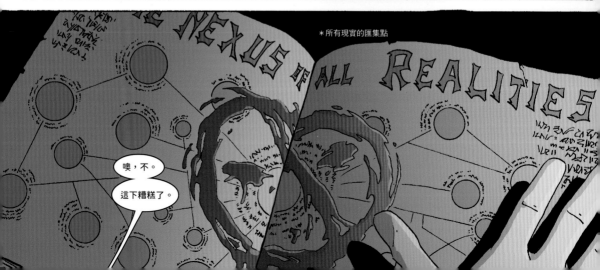

*所有現實的匯集點

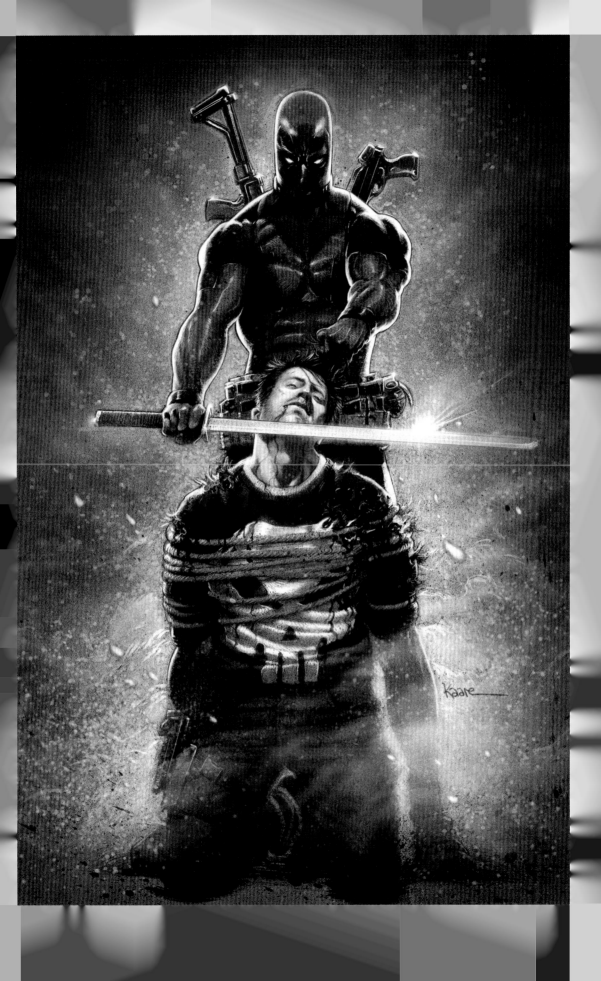

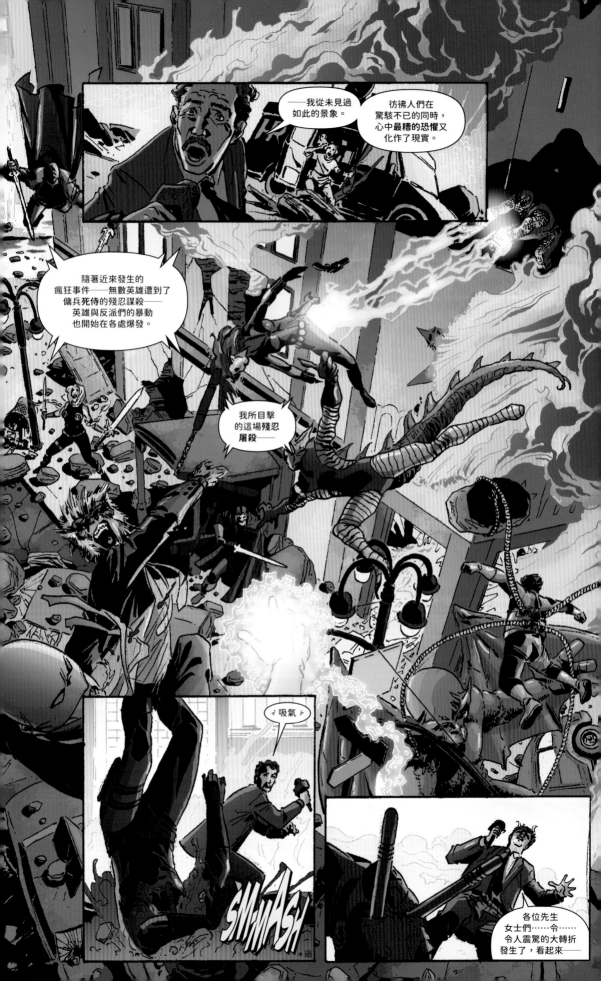

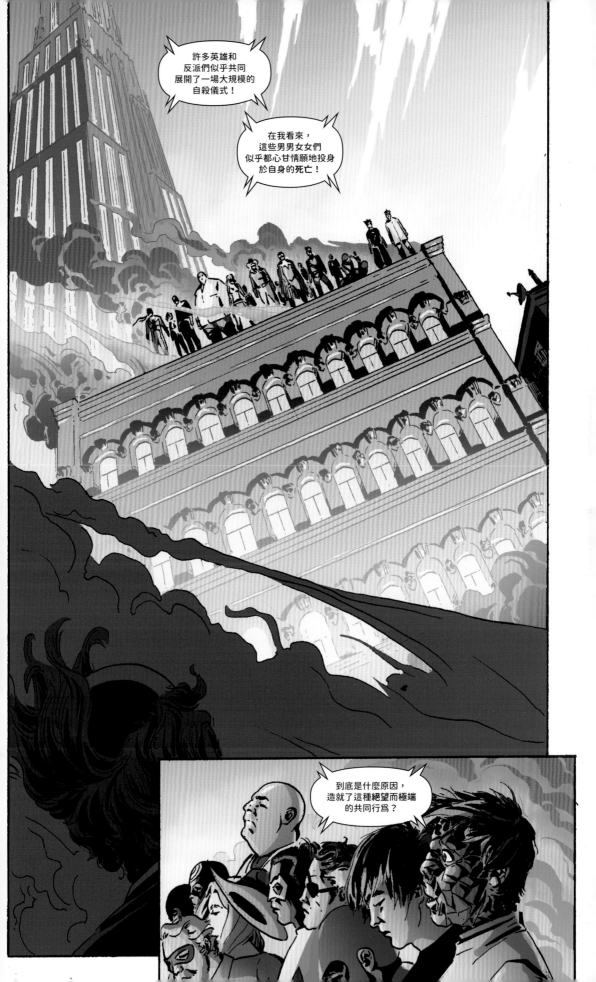

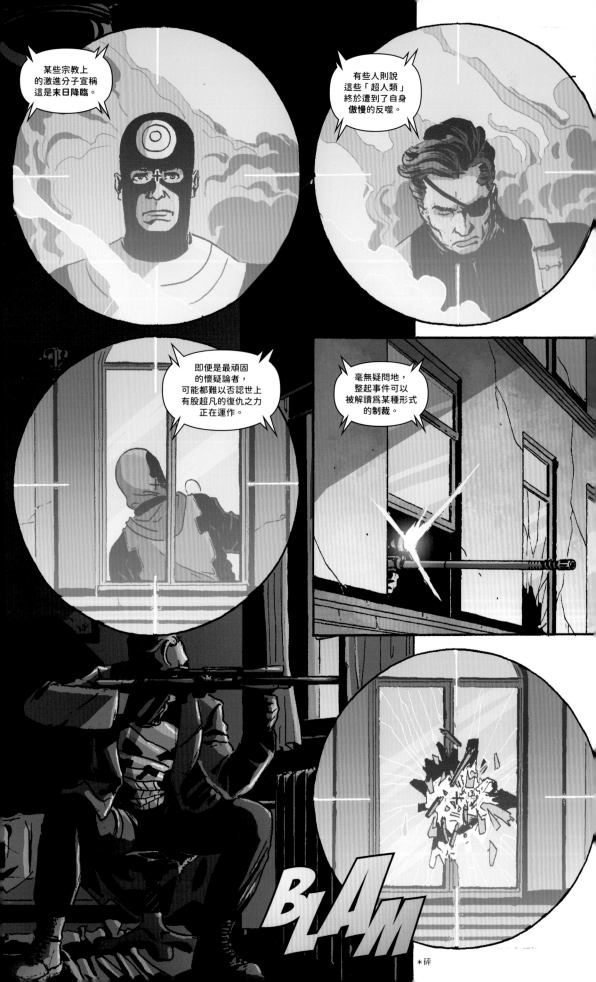

*砰

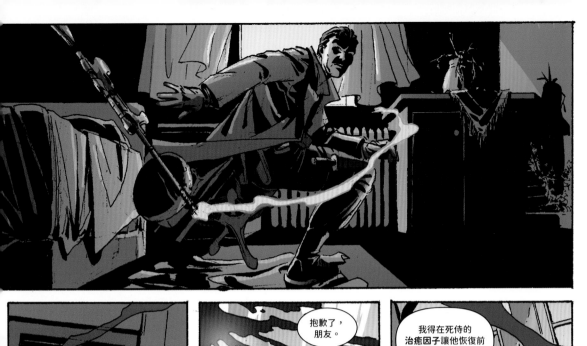

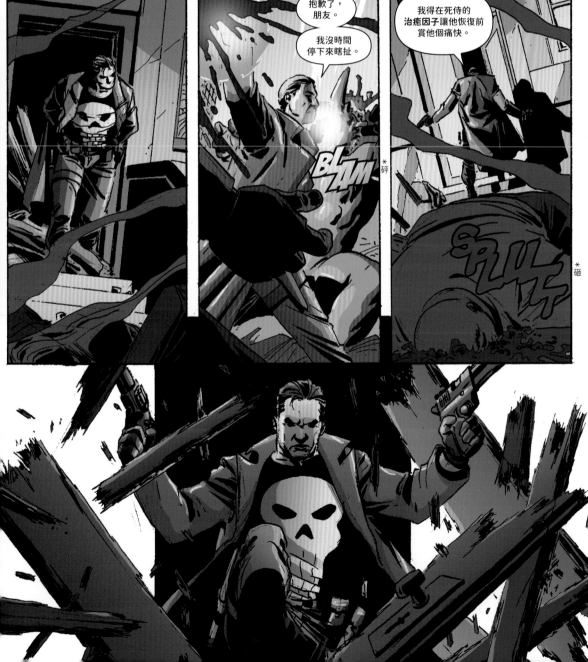

抱歉了，
朋友。

我沒時間
停下來瞎扯。

我得在死侍的
治癒因子讓他恢復前
賞他個痛快。

BL4M *砰

SRLL4 *砸

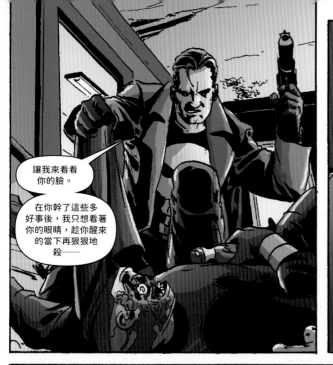

讓我來看看你的臉。

在你幹了這些多好事後，我只想看著你的眼睛，趁你醒來的當下再狠狠地殺——

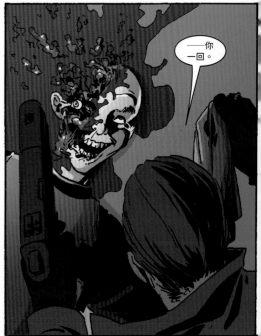

——你一回。

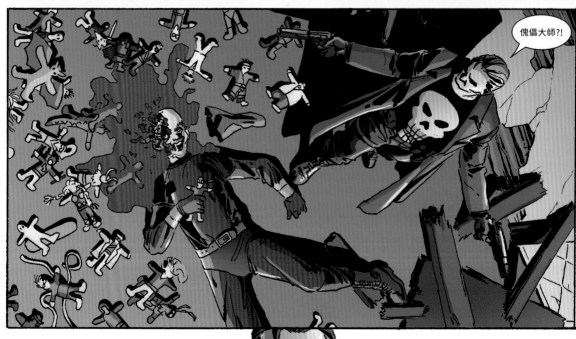

傀儡大師?!

呃——

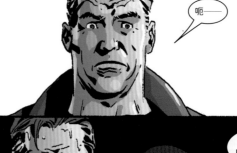

「親愛的日記……」

呃……我是說，「親愛的戰地日誌」……

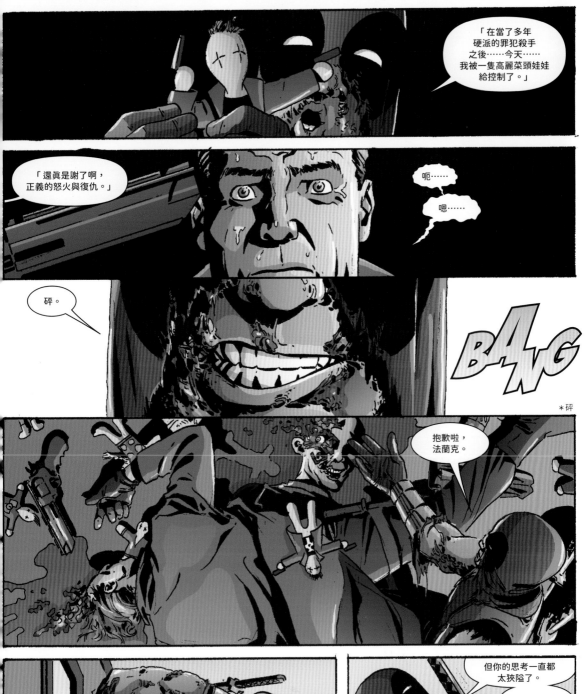

「在當了多年硬派的罪犯殺手之後……今天……我被一隻高麗菜頭娃娃給控制了。」

「還真是謝了啊，正義的怒火與復仇。」

呃……

嗯……

砰。

BANG

*砰

抱歉啦，法蘭克。

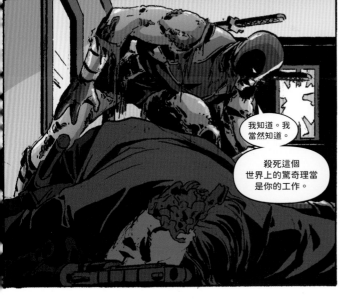

我知道。我當然知道。

殺死這個世界上的驚奇理當是你的工作。

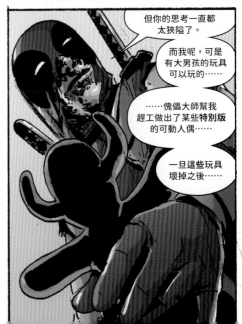

但你的思考一直都太狹隘了。

而我呢，可是有大男孩的玩具可以玩的……

……傀儡大師幫我趕工做出了某些特別版的可動人偶……

一旦這些玩具壞掉之後……

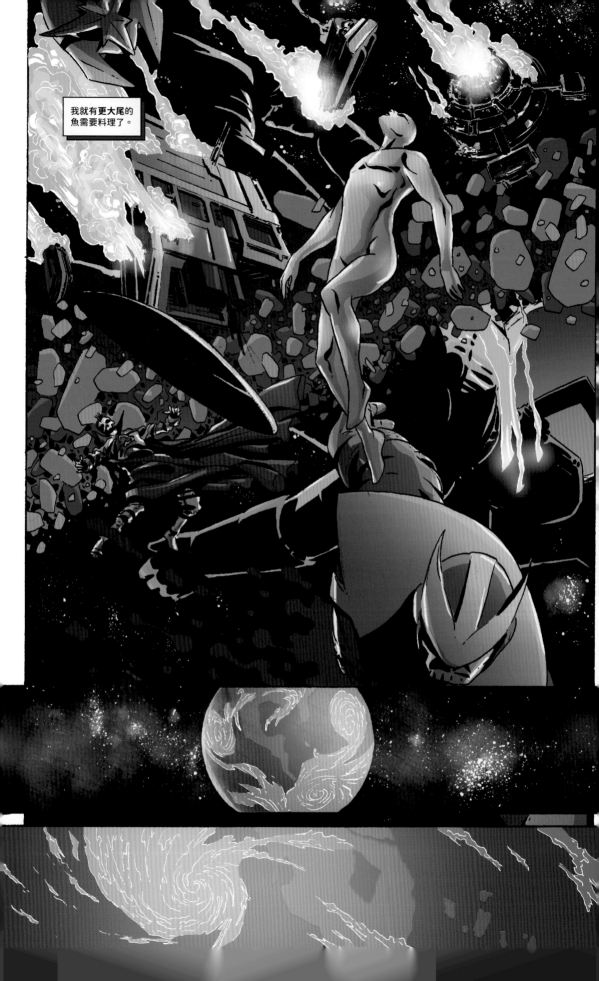

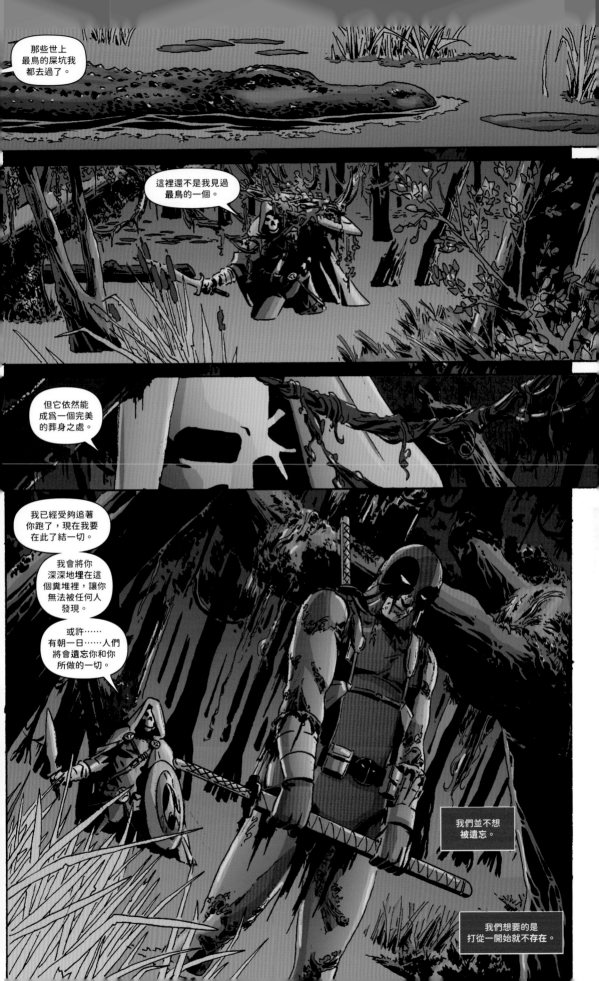

你剛剛說什麼？

我？

我一句話也沒說。

我有開口嗎？

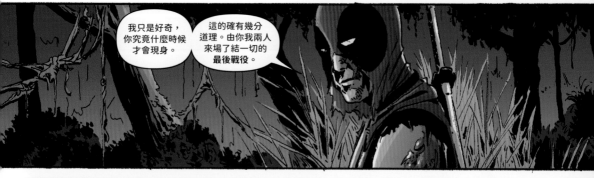

我只是好奇，你究竟什麼時候才會現身。

這的確有幾分道理。由你我兩人來場了結一切的最後戰役。

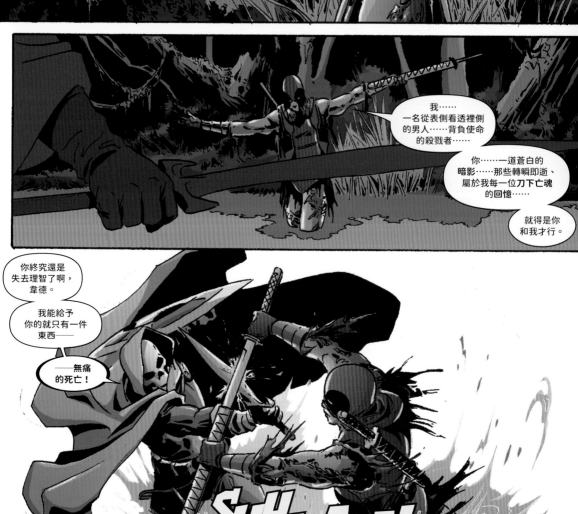

我……一名從表側看透裡側的男人……背負使命的殺戮者……

你……一道蒼白的暗影……那些轉瞬即逝、屬於我每一位刀下亡魂的回憶……

就得是你和我才行。

你終究還是失去理智了啊，韋德。

我能給予你的就只有一件東西──

──無痛的死亡！

SHH-TAANNG

*咻噹

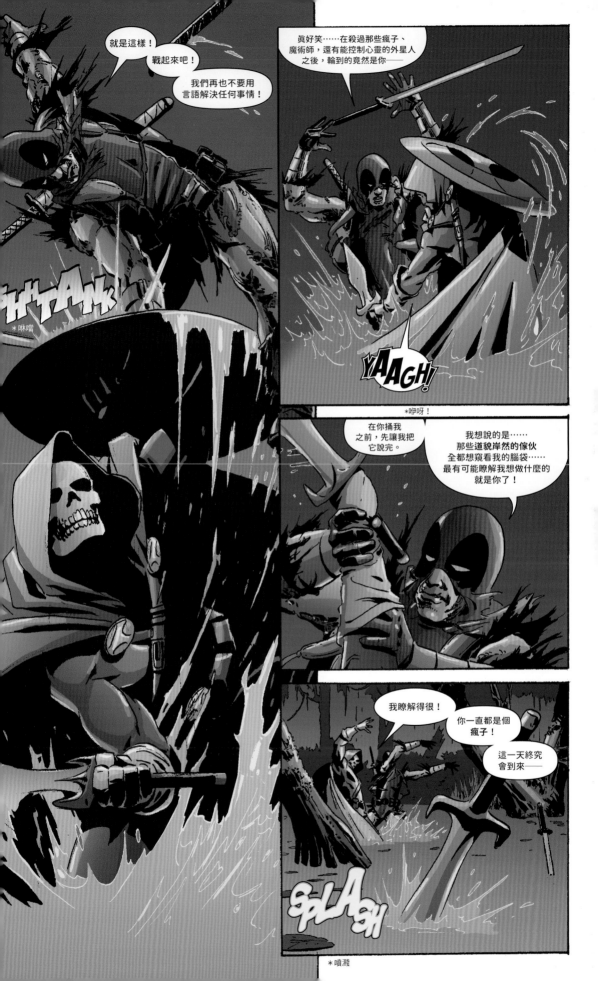

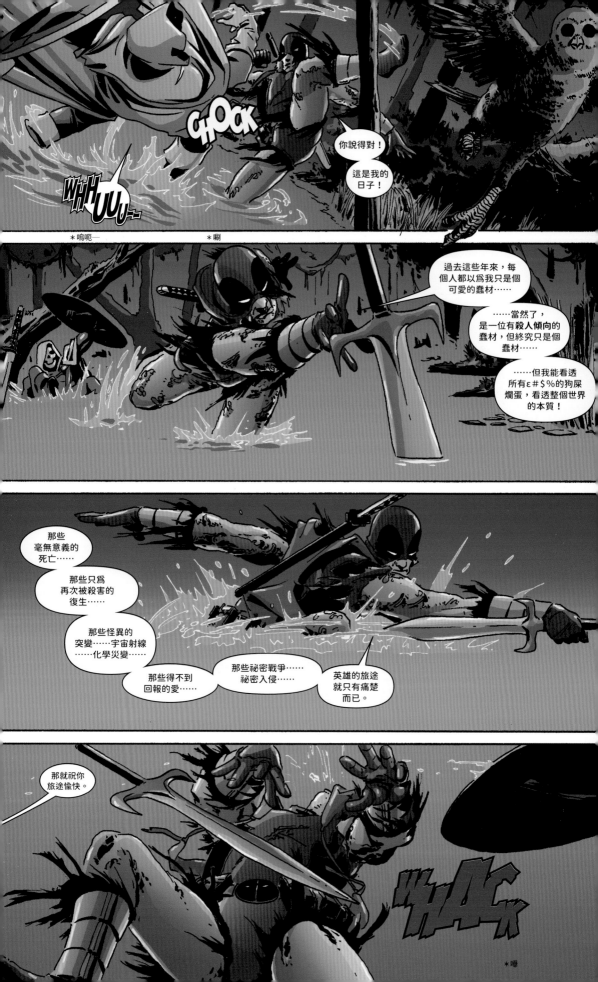

呼嗯……
呼嗯……

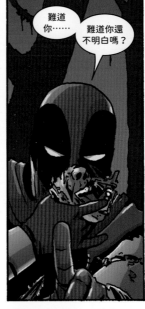

難道你……難道你還不明白嗎？

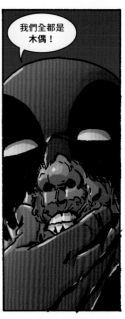

我們全都是木偶！

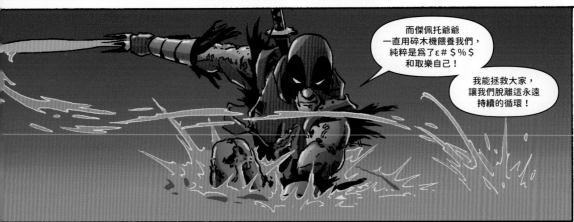

而傑佩托爺爺一直用碎木機餵養我們，純粹是為了ε#＄％＄和取樂自己！

我能拯救大家，讓我們脫離這永遠持續的循環！

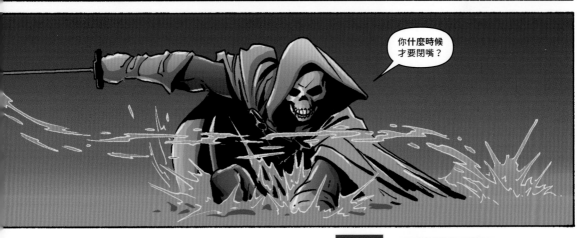

你什麼時候才要閉嘴？

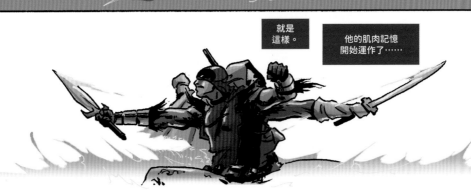

就是這樣。

他的肌肉記憶開始運作了……

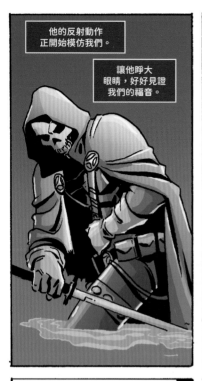

他的反射動作
正開始模仿我們。

讓他睜大
眼睛，好好見證
我們的福音。

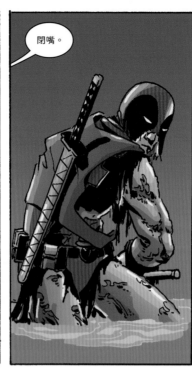

閉嘴。

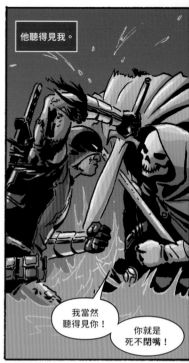

他聽得見我。

我當然
聽得見你！

你就是
死不閉嘴！

你總是說，當你開始模仿
某人時，你就能預測他們
的下一步。

那麼，告
訴我吧。

接下來會
發生什麼？

······

噢······噢
不······

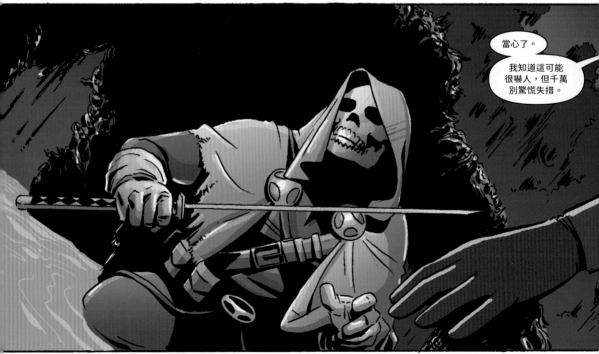

當心了。

我知道這可能
很嚇人，但千萬
別驚慌失措。

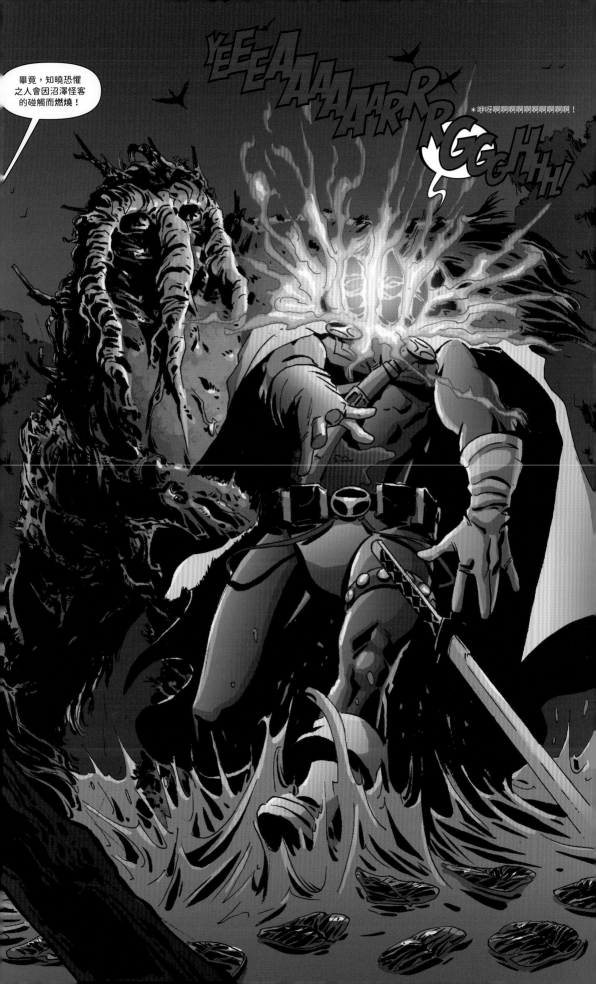

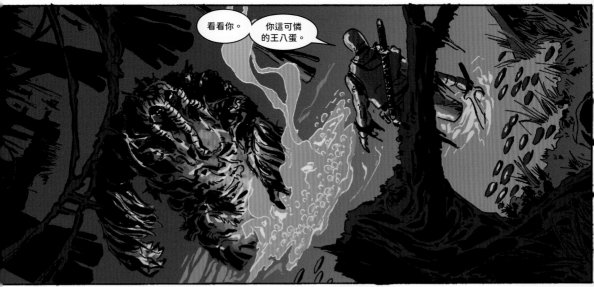

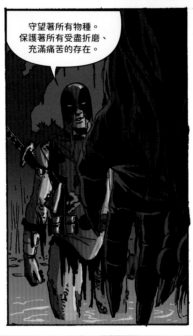
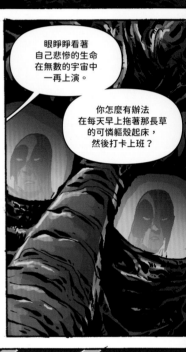
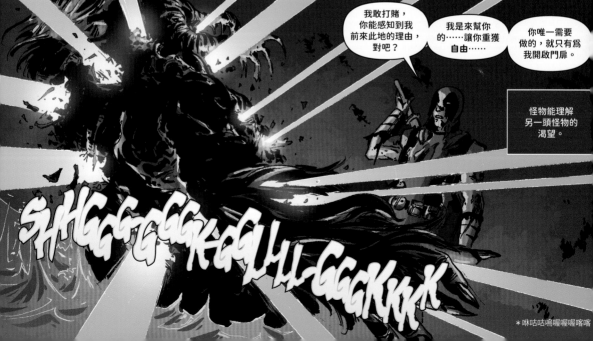

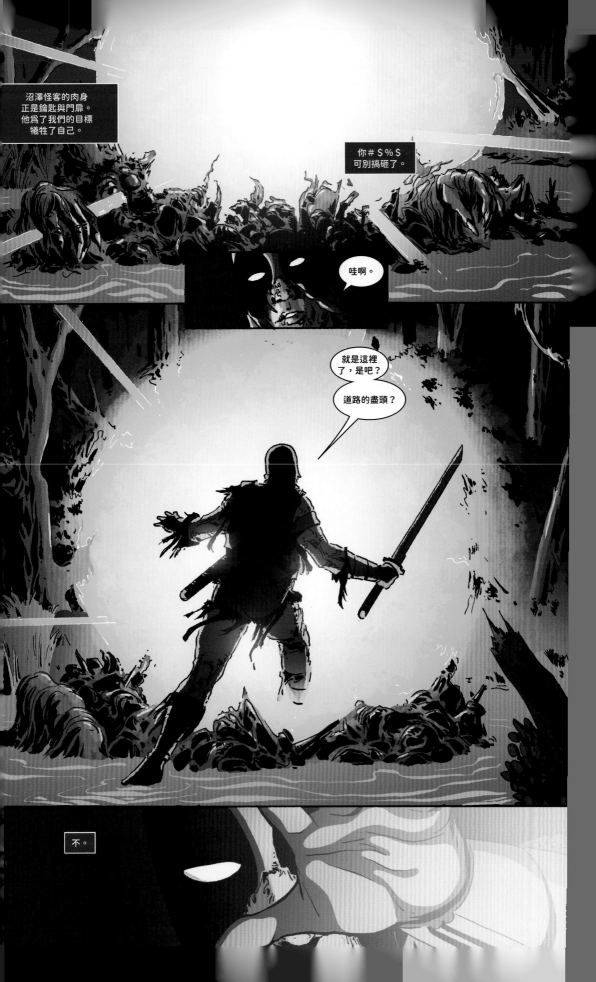

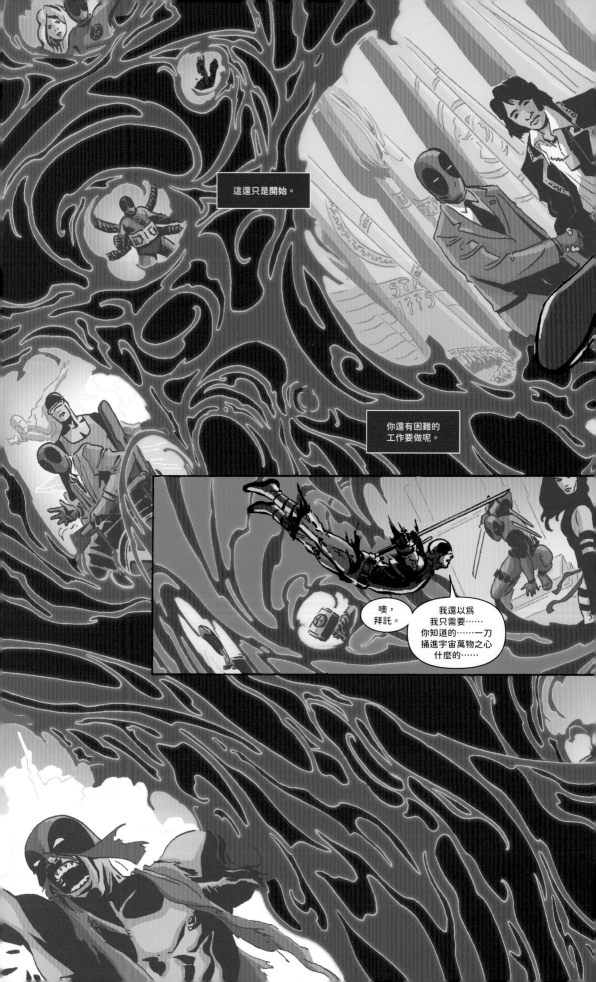

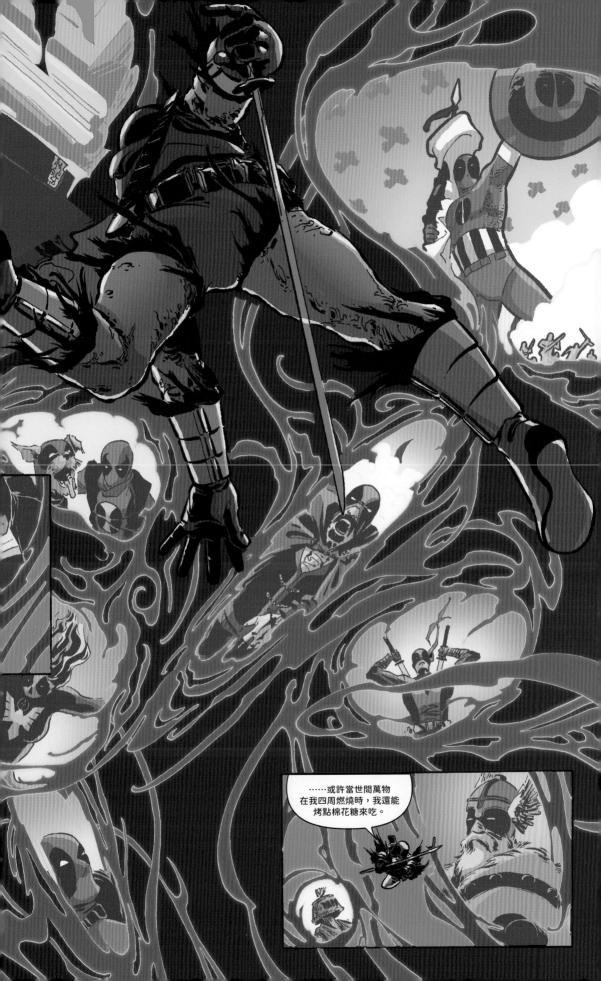

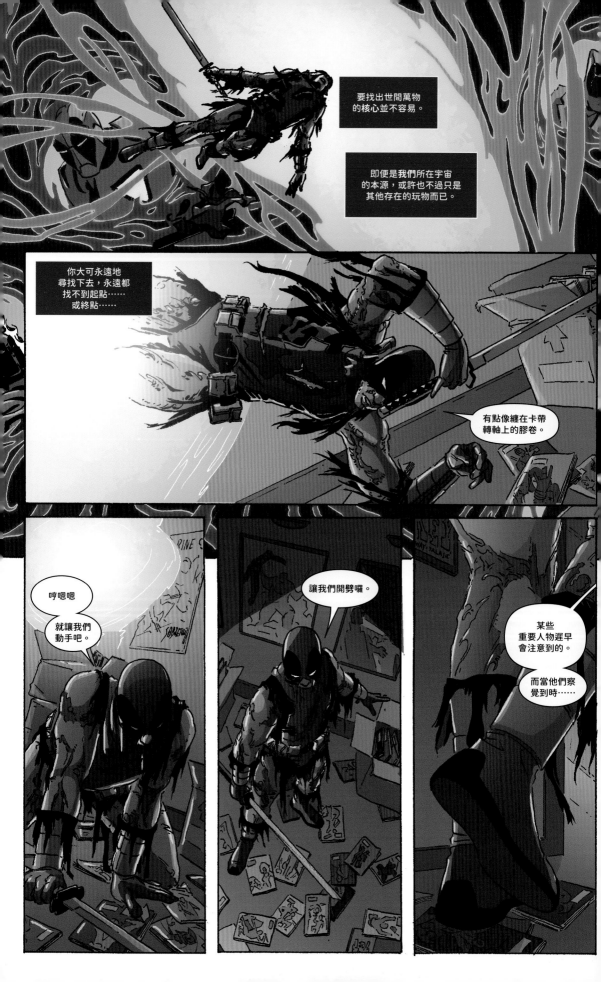

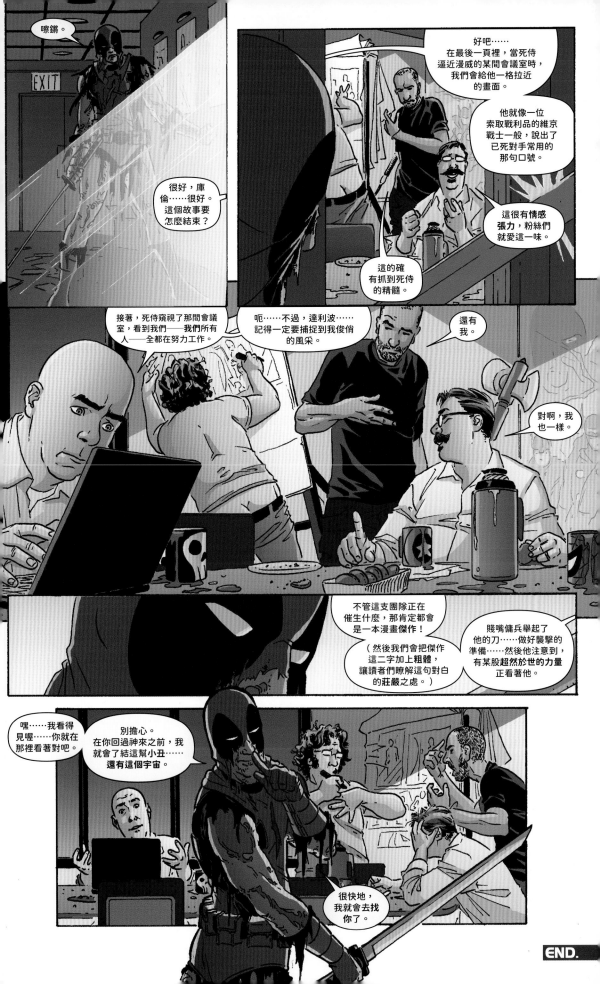

PAGE 17 & 18

Double-Page Spread

17/18.1
Deadpool floats in a cosmic void. Clouds of rippling energy curl around him. His back is to us, and we see dozens of undulating "windows" in time and space rippling open before him. Within each window is a different view of a different alternate reality. Some samples include:

- Kidpool and Dogpool at play.
- Deadpool as a member of X-Force.
- Deadpool Noir.
- Deadpool in a wheelchair and commanding the X-Men.
- Deadpool dressed in a vampire's garb. His mask is torn and he sports vicious-looking fangs.
- Deadpool surrounded by the flames of the Phoenix Force.
- And any other variations of Deadpool you might want to create.

There are many, many of these "windows," stretching back as far as the eye can see, but many cannot be made out clearly. Others may simply have strange close-ups of Deadpool.

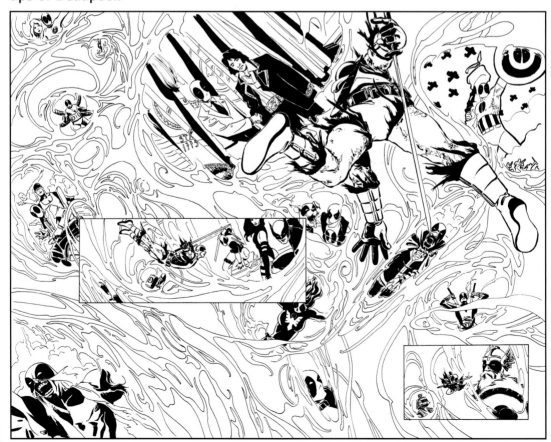

(Third voice): This is only the **beginning**.

2/CAPTION
(Third voice): You have your work cut out for you.

17/18.2
Deadpool "swims" through the void, moving past the "windows" into other realities. He is moving past some of the reflection of Deadpool, who seem to notice him.

3/DEADPOOL: Aw, c'mon.

4/DEADPOOL: I thought I could just... y'know... stab creation in the heart or something...

17/18.3
Close on some of the windows, the "other" Deadpools watching our Deadpool move past.

5/DEADPOOL: ...maybe roast some marshmallows as all existence burns down around me.

PAGE 19

19.1
Deadpool "swims" through the void toward one of the "windows."

1/CAPTION
(Third voice): Finding the **centerpoint** of existence is no easy task.

2/CAPTION
(Third voice): Even the progenitors of **our** universe may be nothing more than the playthings for other entities.

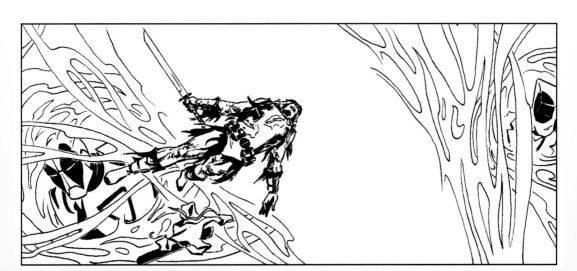

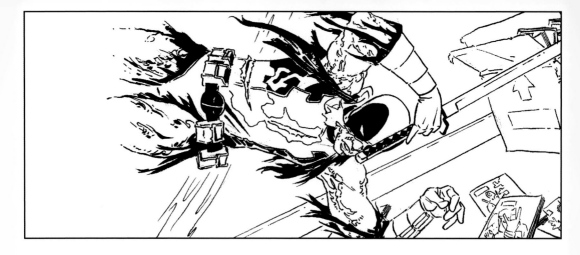

19.2
Close on Deadpool as he begins to pull himself through the portal and into the world beyond.

> 3/CAPTION
> (Third voice): You can hack away forever and never find the beginning... or the end...
>
> 4/DEADPOOL: Sorta like tape stuck on the spool.

19.3
Deadpool is now on the carpeted floor of a dimly lit room. The portal is closing behind him. He is hunkered down, trembling, as if traveling through the portal was painful and sickening. There are comic books—Marvel comic books—spread out on the floor around him.

> 5/DEADPOOL
> (Small, weak): Hrrggg
>
> 6/DEADPOOL
> (Small): Let's do that, then.

19.4
Deadpool stands up straight, noticing the comics. Marvel comics are spread out all over the floor around him. He is in a storeroom of sorts. All around are metal shelves filled with boxes (not comic book boxes, but regular shipping boxes) and stacks of loose comics and graphic novels. A tattered poster — maybe of an older Deadpool comic cover — is on the wall.

> 7/DEADPOOL: Let's start **hacking**.

19.5
On Deadpool's feet as he walks toward a door. He steps on copies of Deadpool, crumpling them.

Sooner or later, somebody important's gonna take note.

9/DEADPOOL: And when they do...

PAGE 20

20.1
In the hall as Deadpool, holding his sword at the ready, moves toward another source of light. The hallway is lined with framed posters for Marvel comic books.

1/DEADPOOL: Snikt.

20.2
Approaching a meeting room door, Deadpool keeps his back to the wall as he sneaks closer. A flickering light comes from within. Voices come from within the room.

2/AXEL
(Off-panel): All right. All right. How does it end?

3/CULLEN
(Off-panel): Okay... on the last page we'll have a close shot of Deadpool as he approaches the door to one of Marvel's conference rooms.

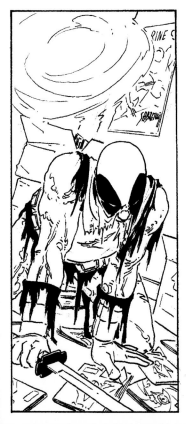 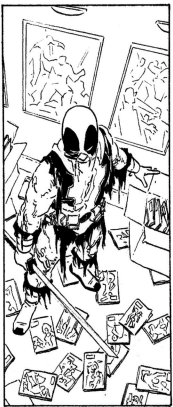

3/CULLEN (Off-panel):	Like a Viking warrior claiming the rewards of battle, he utters a catch-phrase oft-attributed to his now-dead rival.
4/JORDAN:	That's **pathos** there. Fans'll eat that up!

20.3
Angle past Deadpool as he looks into the room. We are looking into a meeting room. AXEL, JORDAN, CULLEN, and DALIBOR are gathered around a conference table. Cullen has a laptop open on the table before him. He types furiously. Dalibor is standing, thumb nailing THIS PAGE on a whiteboard or flipchart. The table is messy, covered in coffee cups and crumb-covered plates.

5/CULLEN:	Then Deadpool peers into the room to see **us**—all of us—hard at work.
6/CULLEN:	All right... but Dalibor... make sure you capture exactly how handsome I am.
7/AXEL:	Me, too.
8/JORDAN:	Yeah, me too.

20.4
Deadpool prepares his sword, readies himself to strike.

9/CULLEN (Off-panel):	Whatever this team is working on, it's a comic book **masterpiece**!
10/CULLEN (Off-panel):	(And we'll **bold** "masterpiece" just so the readers get the **gravitas** of that sentence.)
11/CULLEN (Off-panel):	The merc with a mouth raises his sword... ready to strike... when he notices some **otherworldly force** watching him.

20.5
Deadpool pauses, looking right at the reader. He holds a finger to his mouth as if to say "shhhhhhhh."

12/DEADPOOL:	Hey... I see you out there... watching...
13/DEADPOOL:	Don't worry. I'll be done with these **jokers**... and this **universe** before you know it.
14/DEADPOOL:	I'll find **you** soon enough.

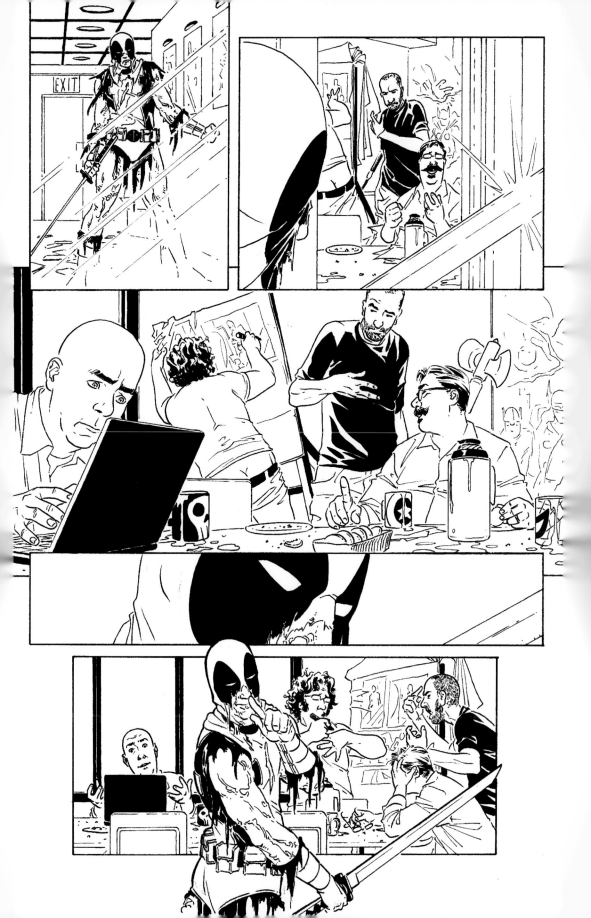

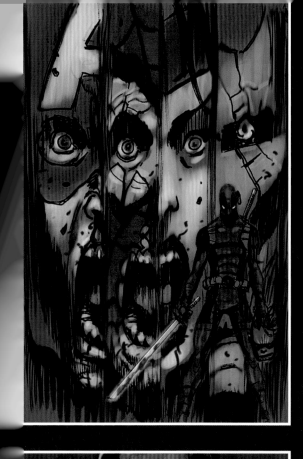

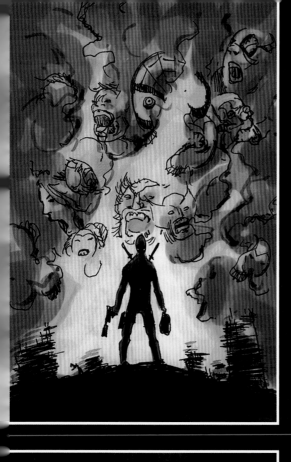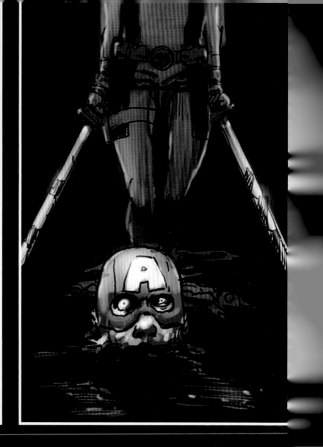

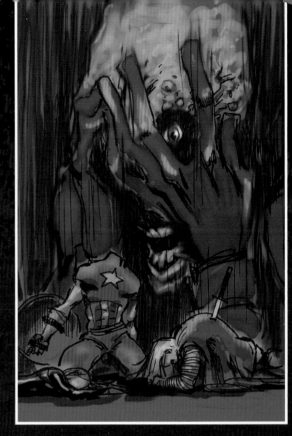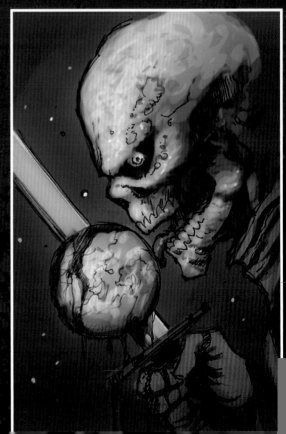